WILTSHIRE
IN PHOTOGRAPHS

DIANE VOSE

AMBERLEY

First published 2022

Amberley Publishing
The Hill, Stroud
Gloucestershire, GL5 4EP

www.amberley-books.com

Copyright © Diane Vose, 2022

The right of Diane Vose to be identified as the Author of this work has been
asserted in accordance with the Copyrights, Designs and Patents Act 1988.

ISBN 978 1 4456 9493 1 (print)
ISBN 978 1 4456 9494 8 (ebook)

British Library Cataloguing in Publication Data.
A catalogue record for this book is available from the British Library.

Typesetting by SJmagic DESIGN SERVICES, India.
Printed in the UK.

ACKNOWLEDGEMENTS

I would like to thank my wonderful parents, Christine and William Vose; sister, Carole Varga; and grandparents, Ken and Helen Forsythe, for their support and encouragement over the years with my interest and love of photography. It was my dad who supplied the money to purchase my first camera – the 110 – at aged seven, which was then put to good use in taking pictures of friends, family and landscapes. I would also like to thank former sub-editor Jo Bayne, who I worked with for many years on the *Wiltshire Gazette* and *Herald*, for helping me write the introduction to this book.

Thanks to everyone at Bowood House and Gardens for allowing me to photograph the changing seasons at this beautiful Wiltshire landmark. Thank you to Help for Heroes, who allowed me to photograph their home base at Tedworth House in Tidworth. I would also like to thank the Facebook group 'Beautiful Wiltshire', who inspired me to visit so many wonderful locations for the book. Thanks to Angeline Wilcox at Amberley Publishing, who saw my images and approached me about doing this book on Wiltshire. Thank you also to Jenny Stephens for her help throughout the process.

ABOUT THE PHOTOGRAPHER

Diane Vose is a photographer based in the county of Wiltshire. On moving to the county fifteen years ago she fell in love with Wiltshire's big skies, rolling countryside and historic past. She loves to be outdoors whatever the weather and enjoys walking in the rural landscape, capturing its timeless beauty on camera. Being a former press photographer who travelled extensively while on photographic assignments, Diane was as much captivated by the Wiltshire towns and villages she encountered as she was by the magical landscape she travelled through.

Diane has used Nikon photographic equipment for the past twenty years. Starting with Nikon's first digital camera, the D1, right through to her current camera, D4s, which is combined with 17–35 mm and 70–200 mm lenses. Her former life as a press photographer needed outstanding camera equipment, an eye for a good picture and a great deal of patience, which rather lends itself to her new vocation as a landscape and outdoor photographer.

Twitter: @VoseDiane
Instagram: @vosediane

INTRODUCTION

The beautiful county of Wiltshire boasts two World Heritage sites: Stonehenge and Avebury. These two magnificent Neolithic monuments have fascinated people for thousands of years and continue to draw millions of visitors from across the United Kingdom and around the world. There are a large number of other Neolithic sites in the county, including Silbury Hill, the largest Neolithic mound in Europe, and nearby West Kennet Long Barrow, a large Neolithic chambered tomb.

The Romans and Anglo-Saxons also left their mark upon the landscape with hill forts at Cleyhill, Bratton Camp and 'Ethundun', located in the village of Edington, where King Alfred defeated the Danes in 878 and changed the course of history across the United Kingdom.

Wiltshire is also known for its beautiful landscape. Almost half of the county is designated an Area of Outstanding Natural Beauty. Salisbury Plain covers 300 square miles and is famous for its archaeology. The plain is now used mainly for military training and is closed to the public, which makes it an impressive wildlife haven. The chalk downland landscape supports thirteen types of rare plants and sixty-seven rare invertebrates. Imber, the lost village on the plain, was commandeered by the Ministry of Defence in 1943 as a wartime military training ground – the villagers were evicted from their homes, never to return. The village is open to the public at Christmas every year. The white horses of Wiltshire have become a symbol for the county. There are eight of them, at Westbury, Cherhill, Devizes, Alton Barnes, Pewsey, Hackpen and Broad Town.

Wiltshire also offers the visitor charming villages with chocolate-box views of thatched cottages and parish churches. The villages of Lacock and Castle Combe have been chosen as locations for many films and television period dramas and visitors will probably recognise the gold stone cottages, pretty bridges and streams or quaint high streets. The towns throughout Wiltshire offer independent shopping, weekly markets and history on the doorstep with old buildings, museums and other attractions.

I hope *Wiltshire in Photographs* will give the reader a visual tour of the county, showcasing its ancient past, beautiful countryside and pretty villages and towns. It's a county where the past and the present work together in perfect harmony.

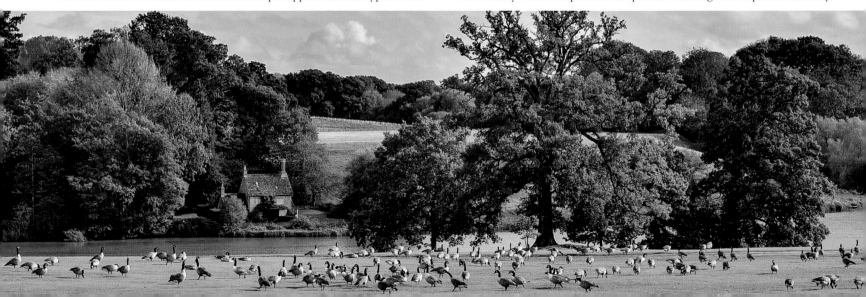

ANCIENT WILTSHIRE

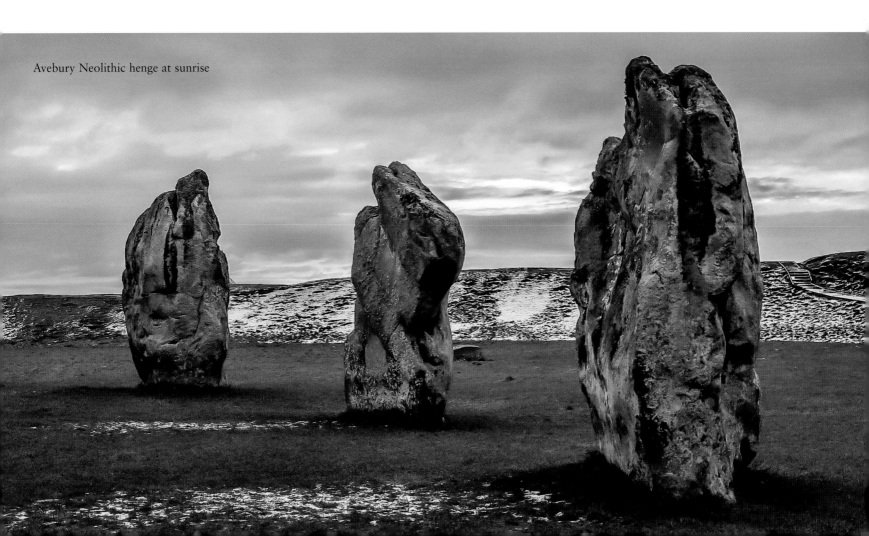

Avebury Neolithic henge at sunrise

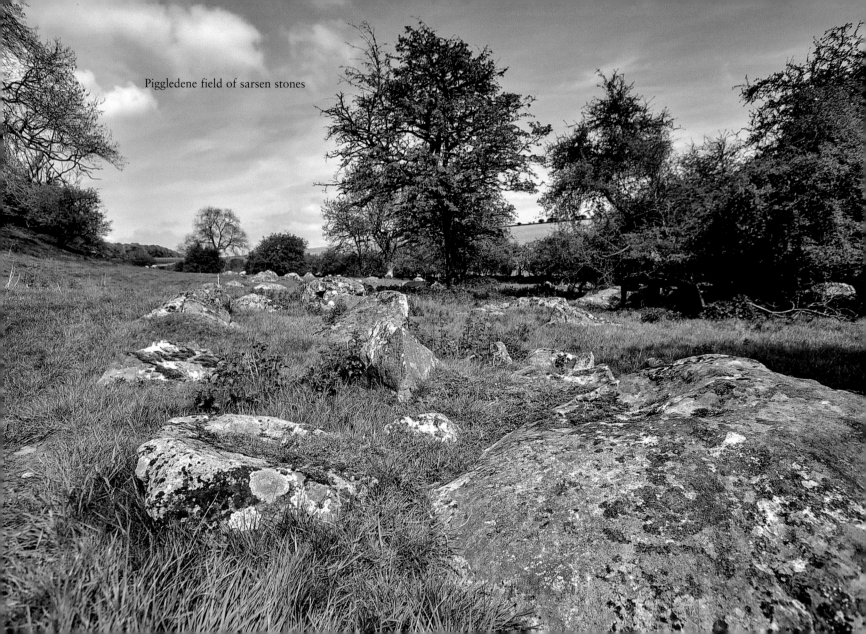

Piggledene field of sarsen stones

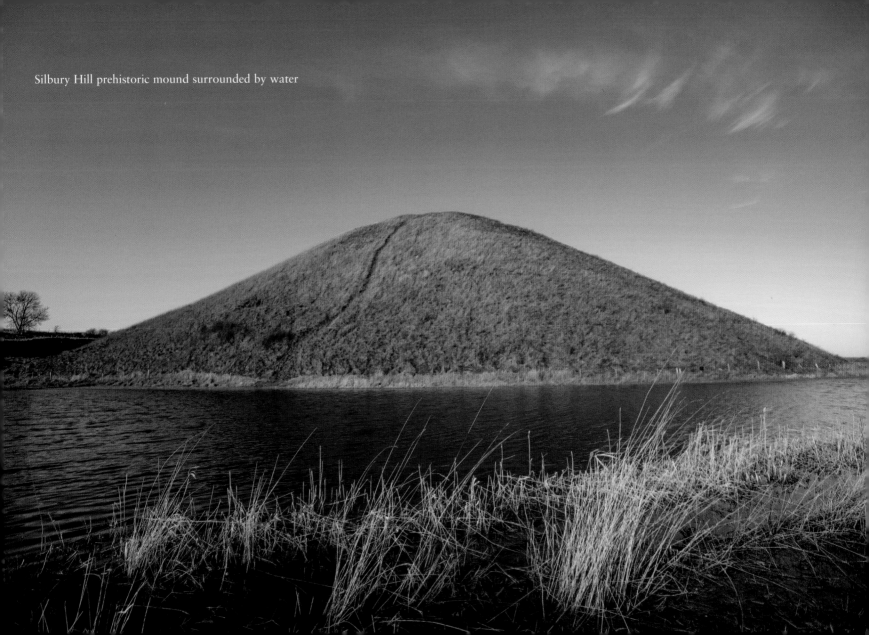

Silbury Hill prehistoric mound surrounded by water

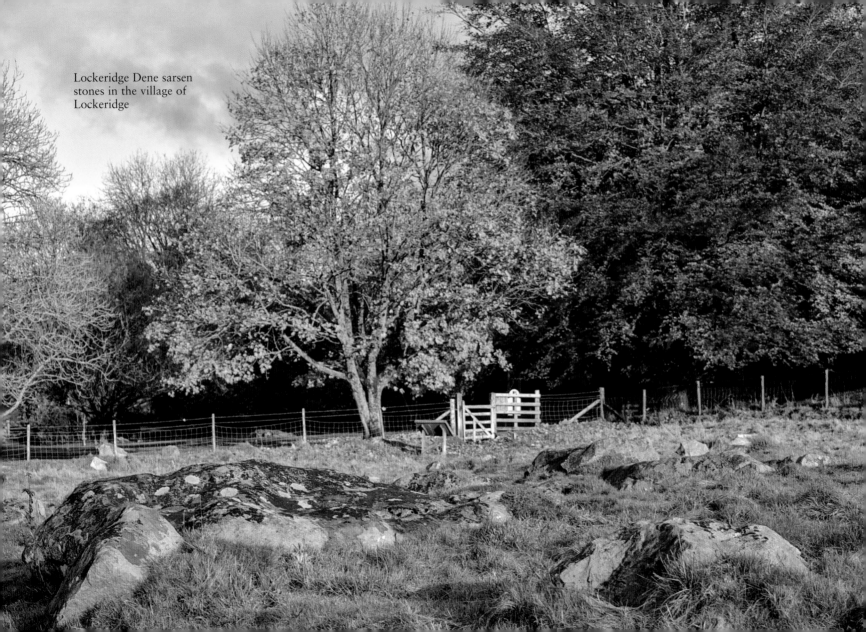

Lockeridge Dene sarsen
stones in the village of
Lockeridge

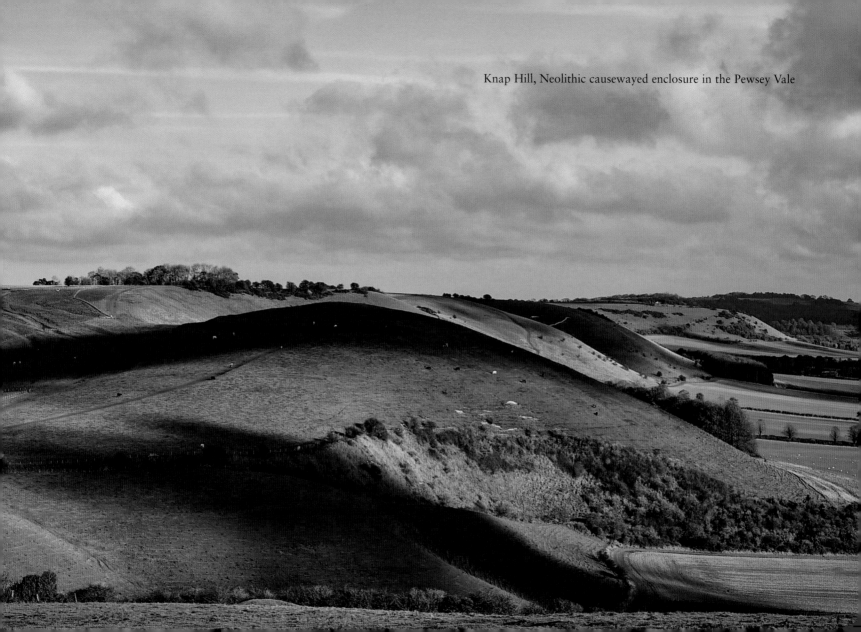

Knap Hill, Neolithic causewayed enclosure in the Pewsey Vale

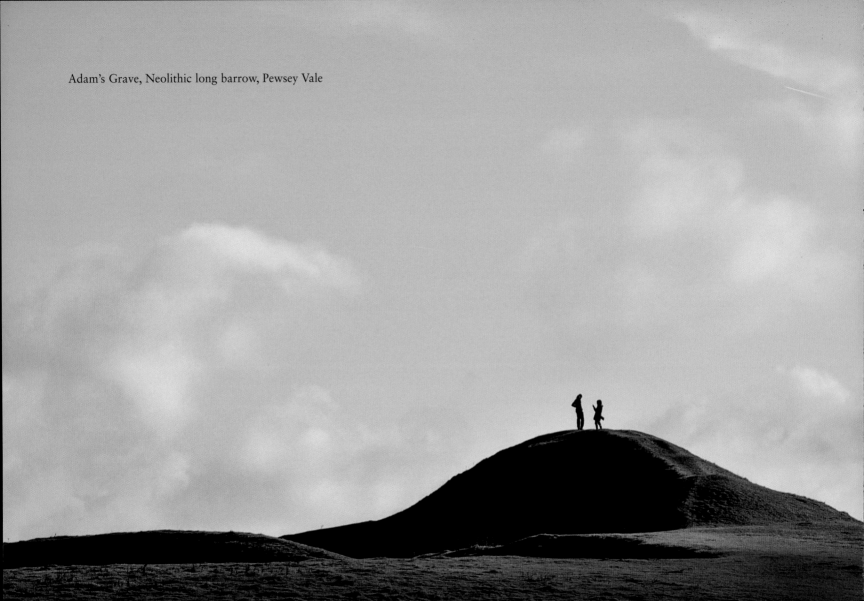

Adam's Grave, Neolithic long barrow, Pewsey Vale

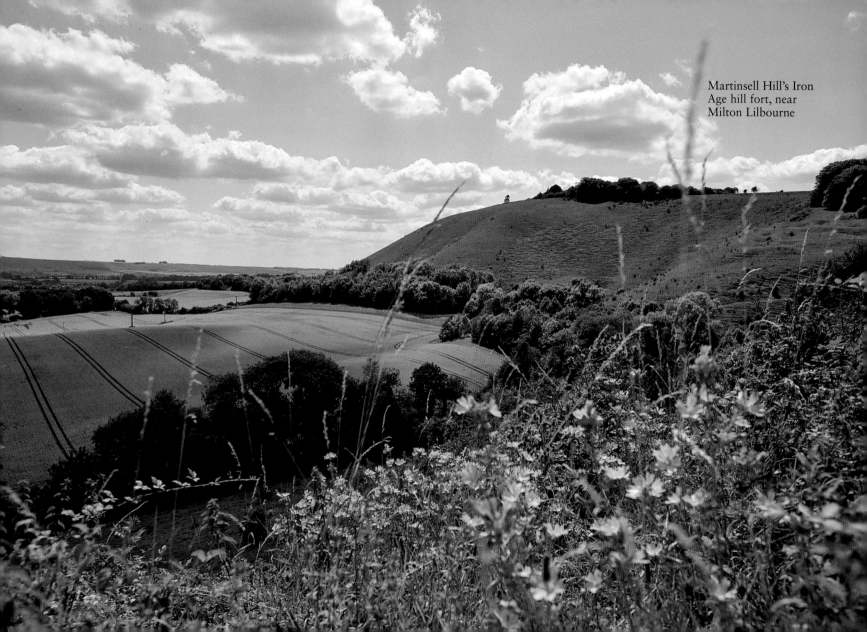

Martinsell Hill's Iron
Age hill fort, near
Milton Lilbourne

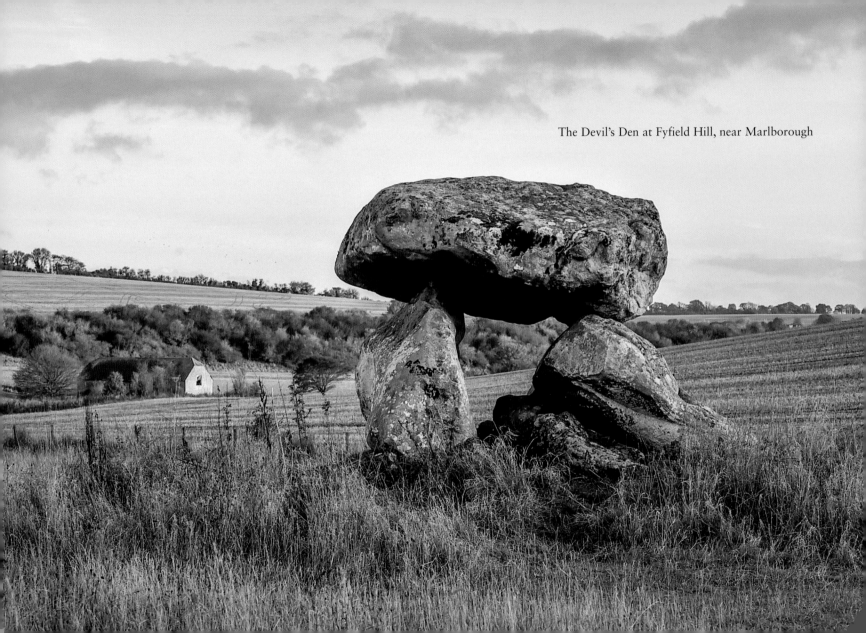

The Devil's Den at Fyfield Hill, near Marlborough

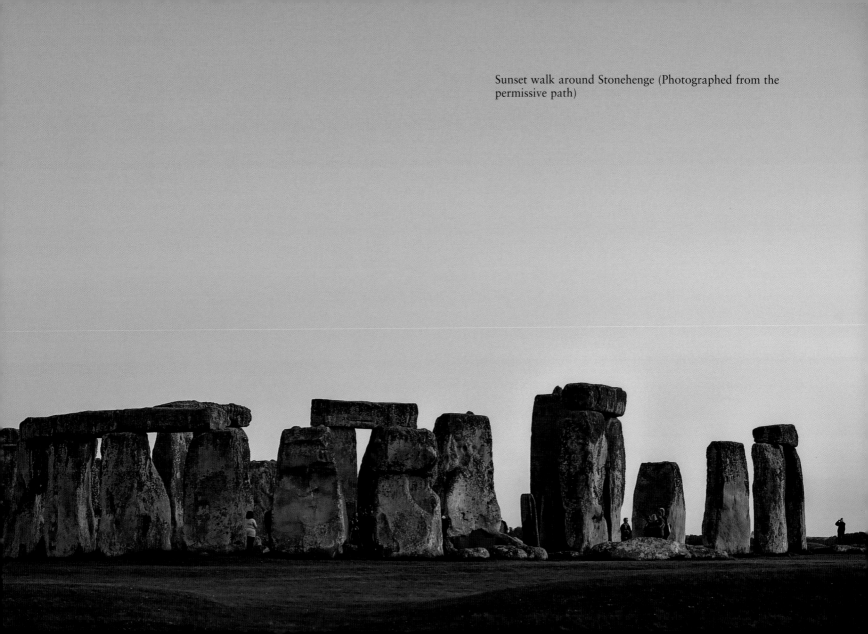

Sunset walk around Stonehenge (Photographed from the permissive path)

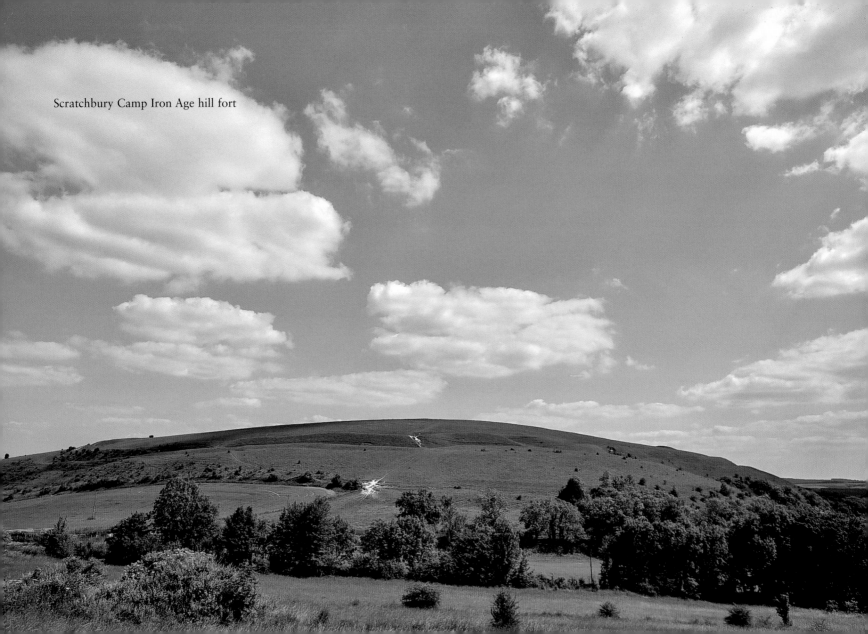

Scratchbury Camp Iron Age hill fort

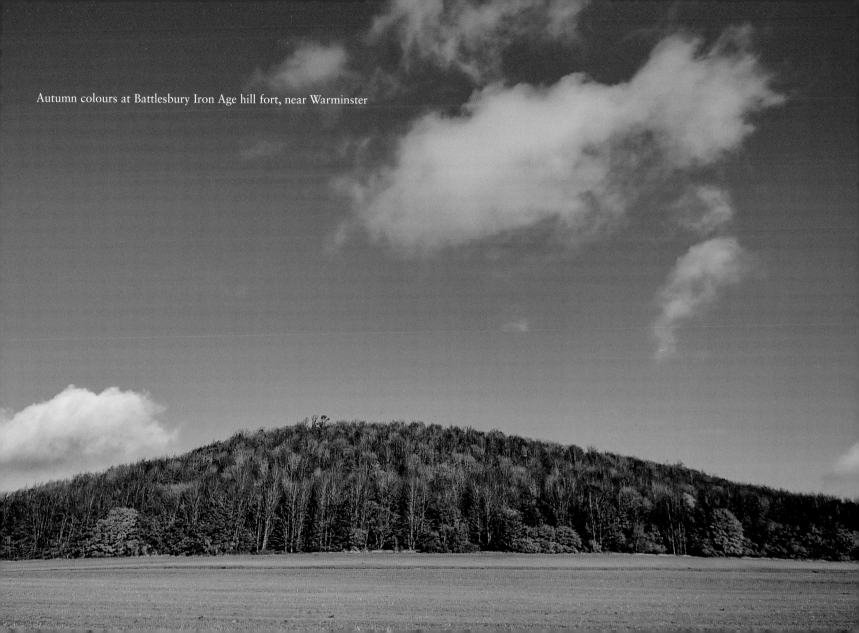

Autumn colours at Battlesbury Iron Age hill fort, near Warminster

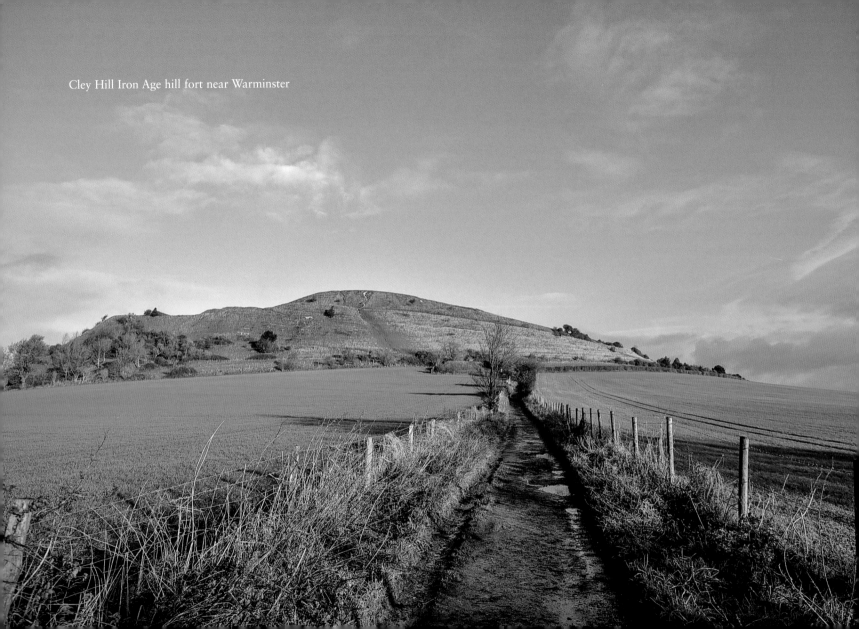

Cley Hill Iron Age hill fort near Warminster

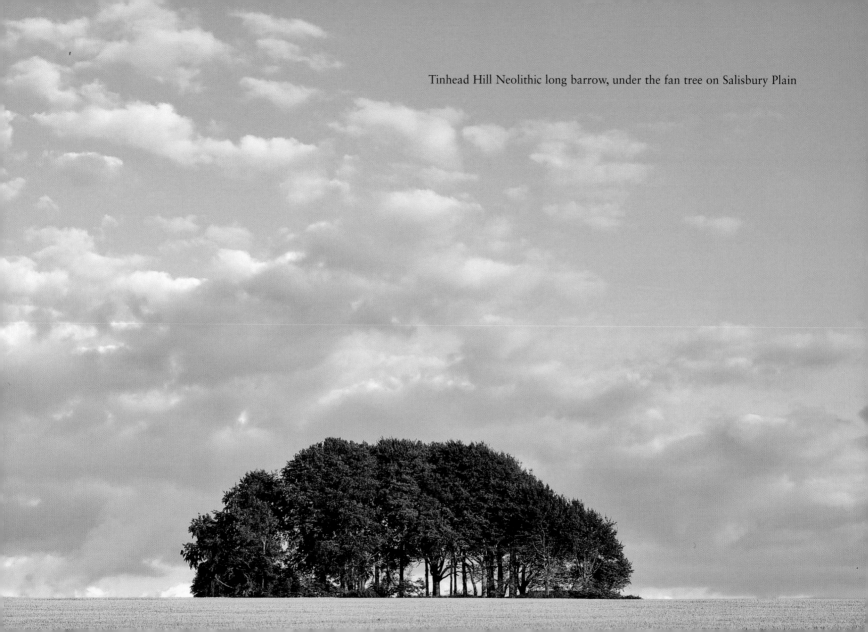

Tinhead Hill Neolithic long barrow, under the fan tree on Salisbury Plain

WILTSHIRE WHITE HORSES

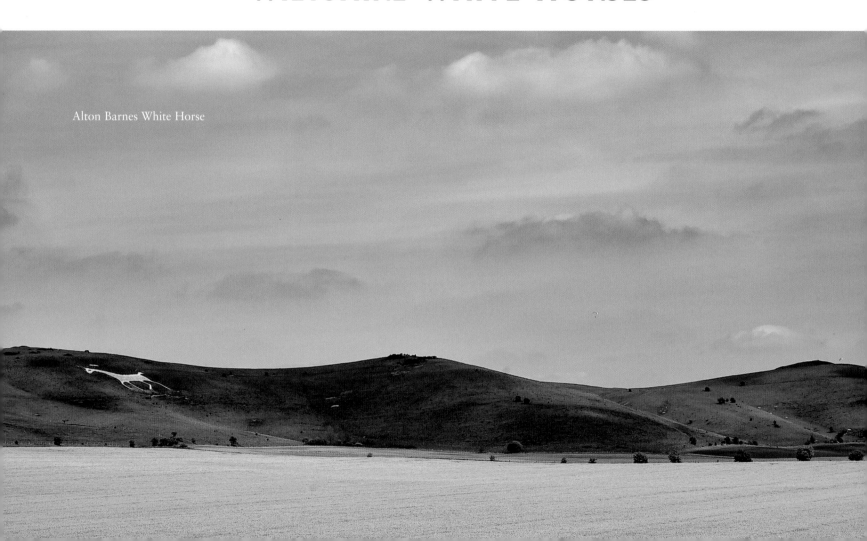

Alton Barnes White Horse

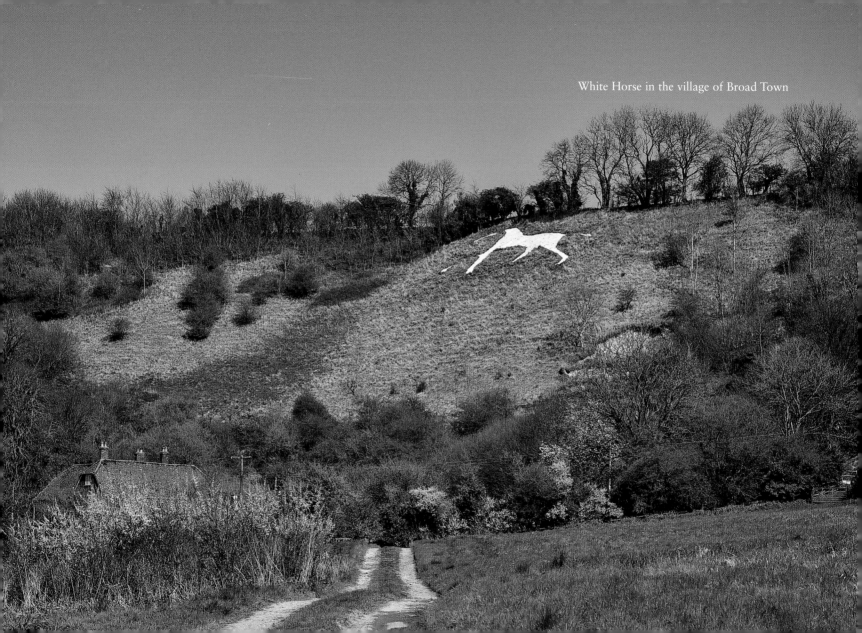
White Horse in the village of Broad Town

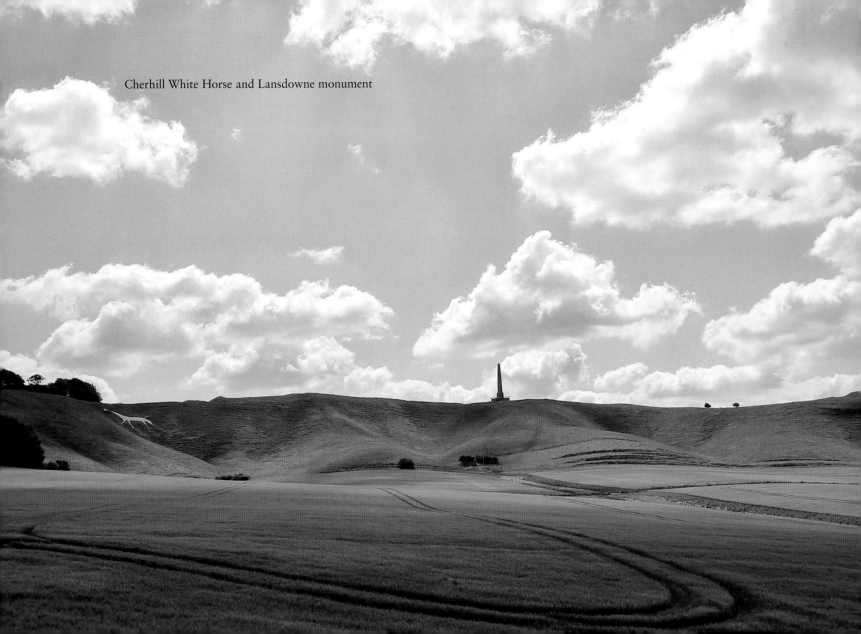

Cherhill White Horse and Lansdowne monument

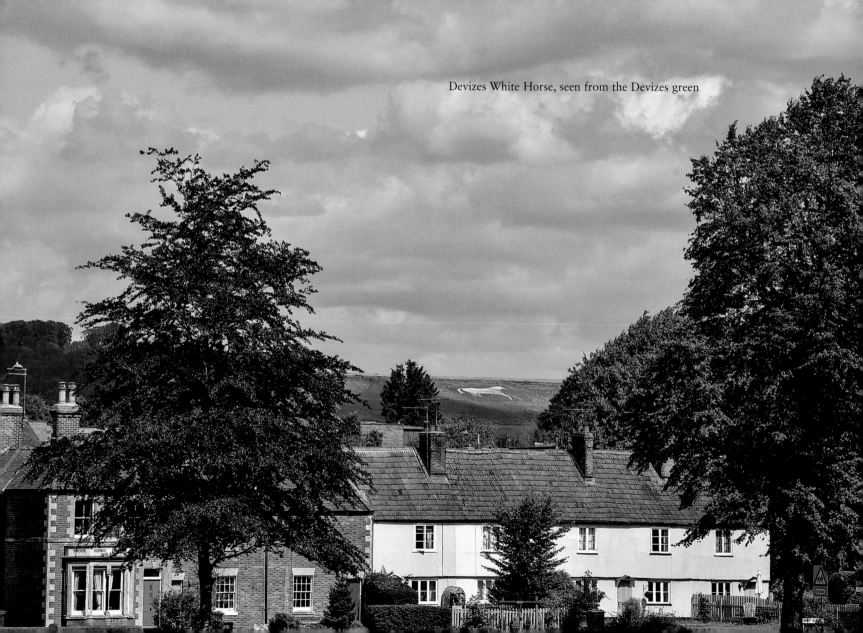

Devizes White Horse, seen from the Devizes green

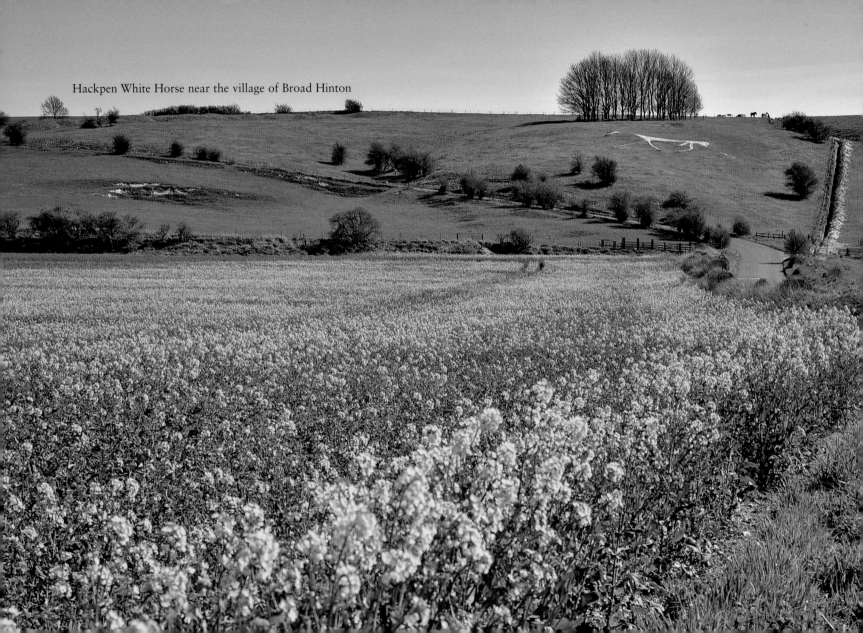

Hackpen White Horse near the village of Broad Hinton

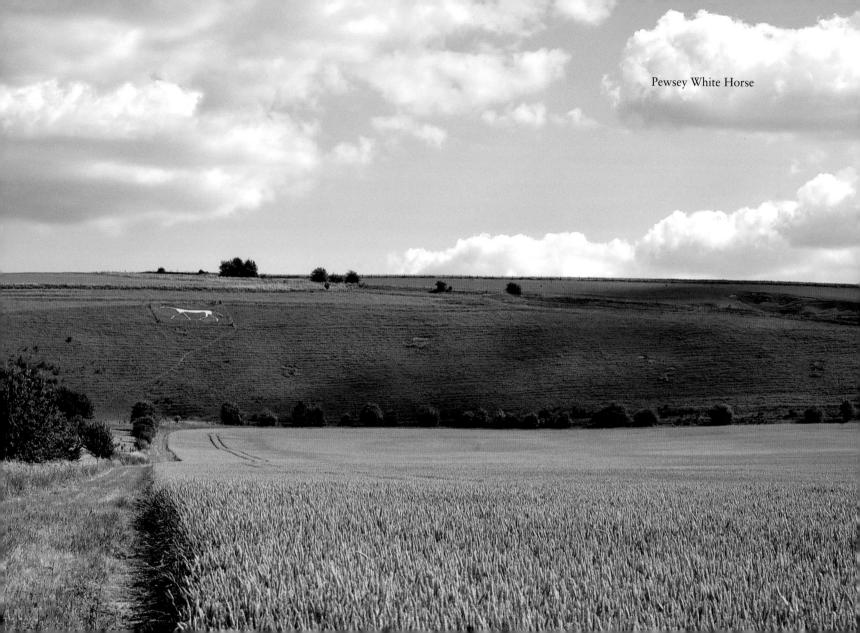

Pewsey White Horse

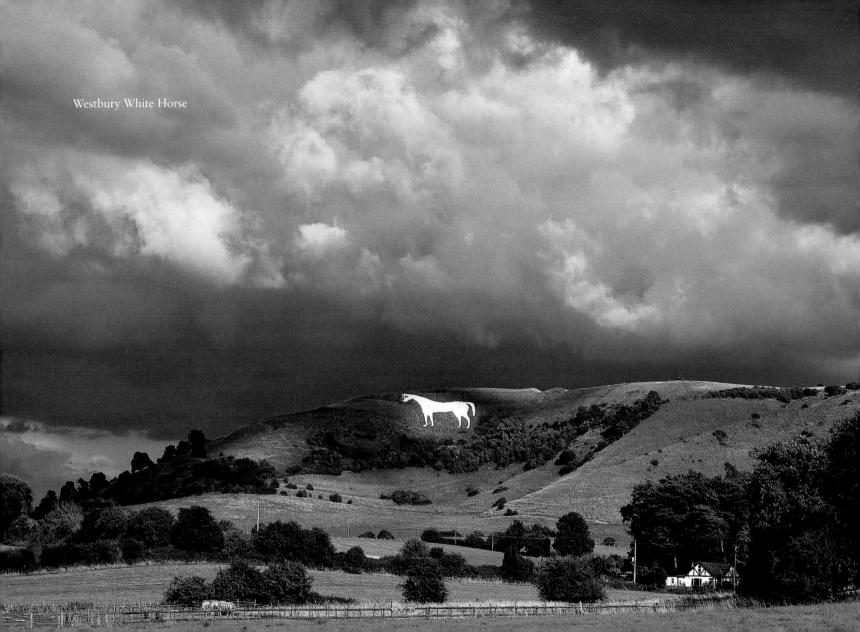

Westbury White Horse

TOWNS AND CITY OF SALISBURY

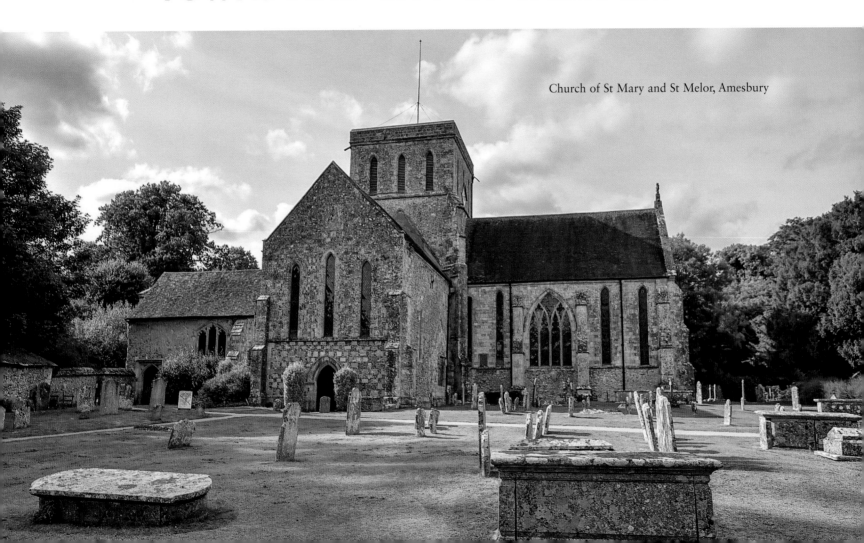

Church of St Mary and St Melor, Amesbury

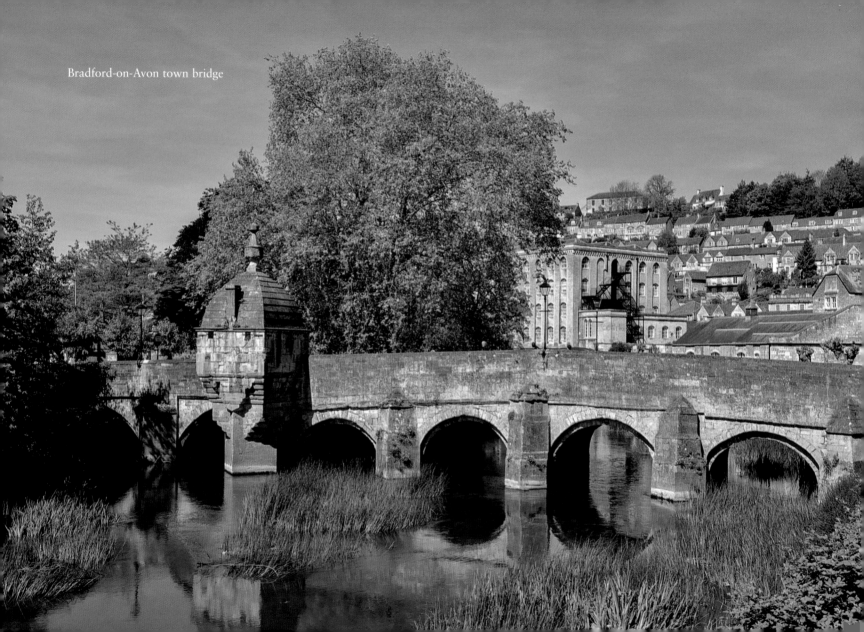

Bradford-on-Avon town bridge

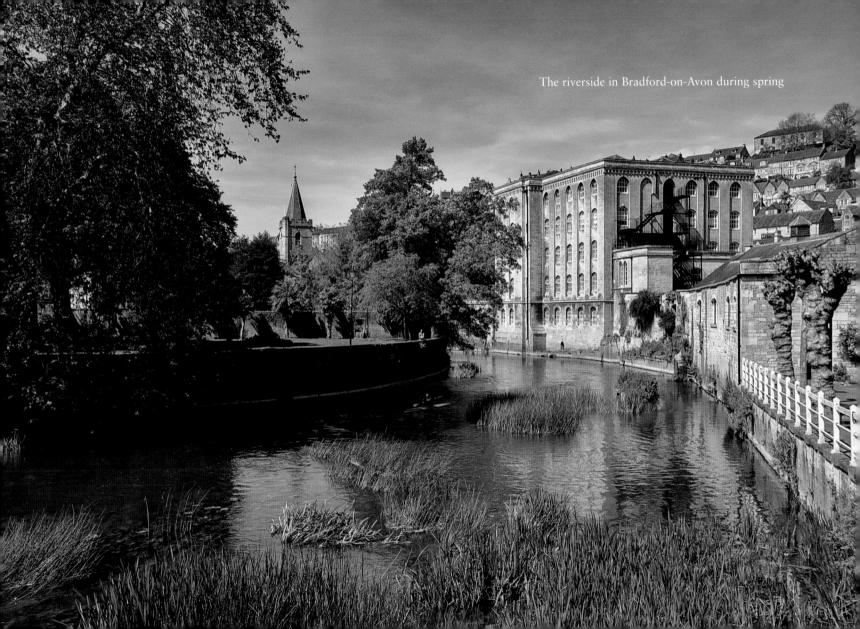

The riverside in Bradford-on-Avon during spring

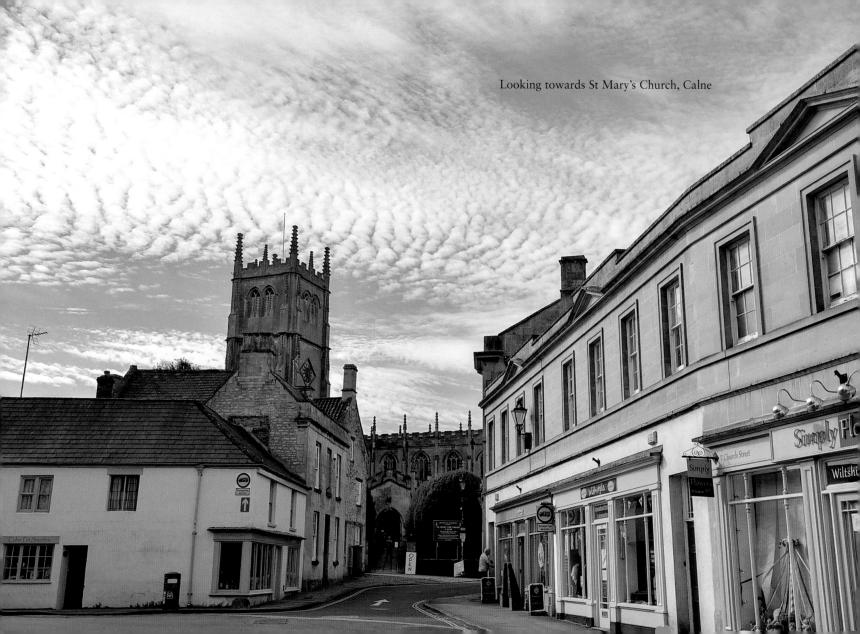

Looking towards St Mary's Church, Calne

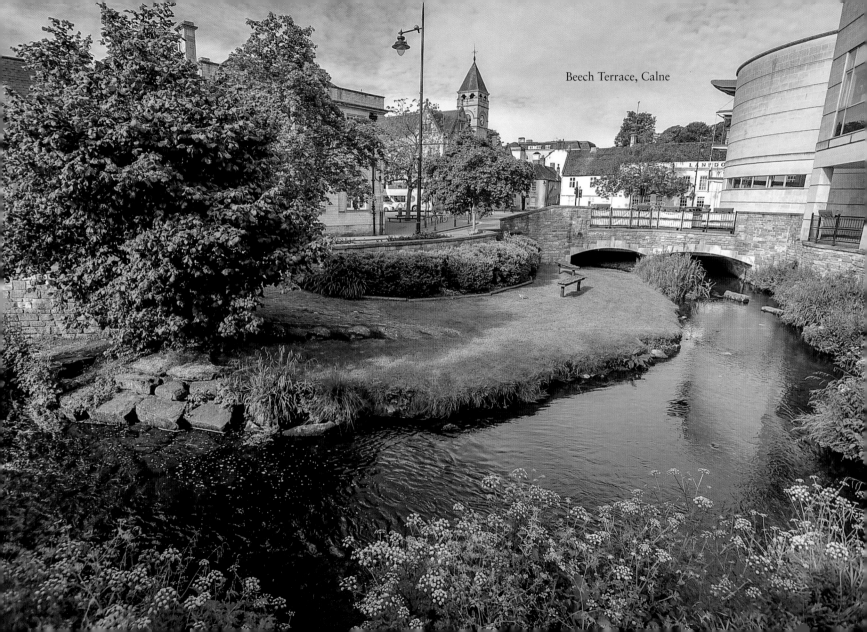

Beech Terrace, Calne

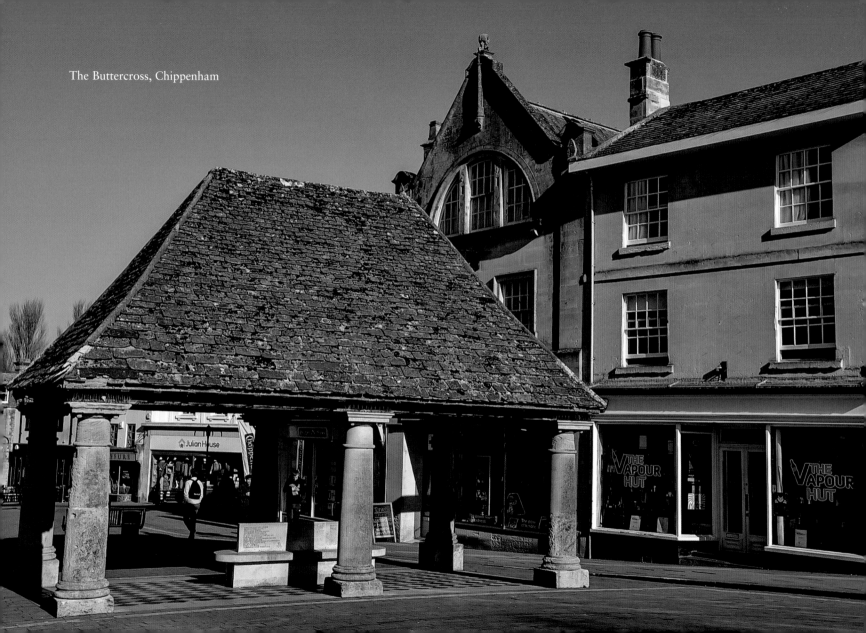

The Buttercross, Chippenham

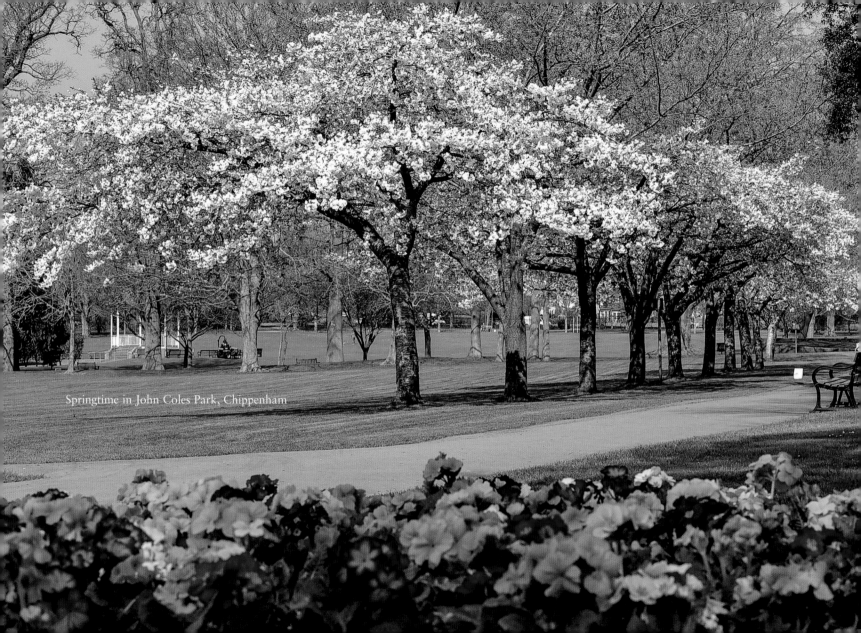

Springtime in John Coles Park, Chippenham

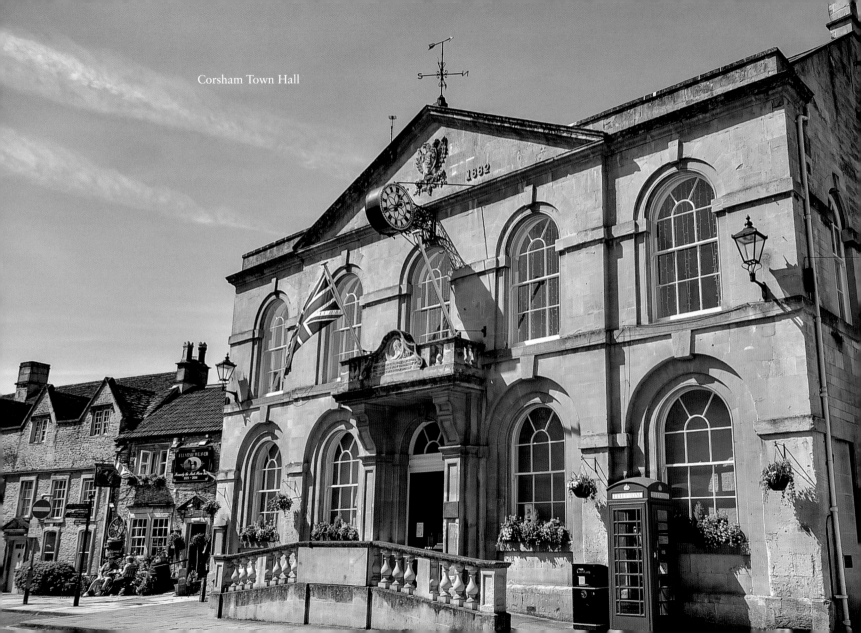

Corsham Town Hall

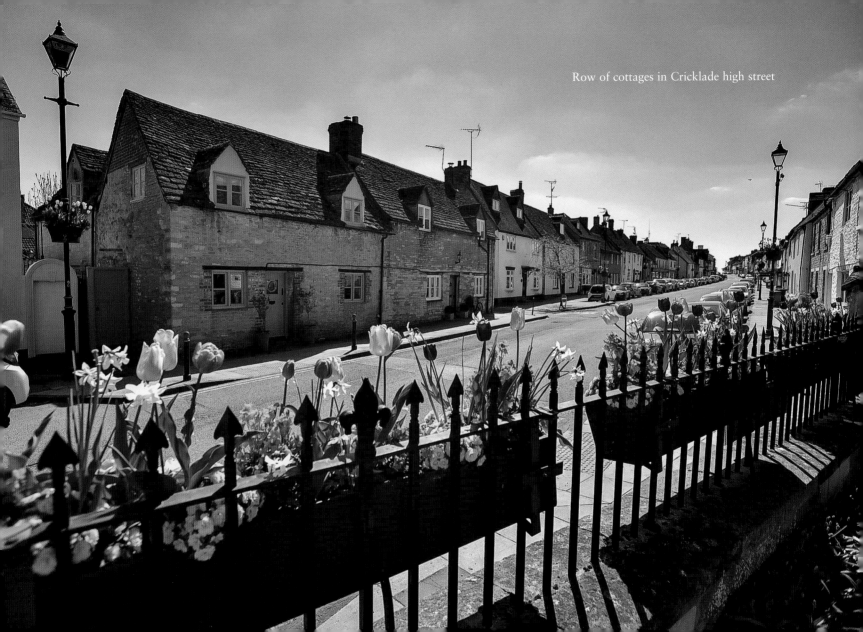

Row of cottages in Cricklade high street

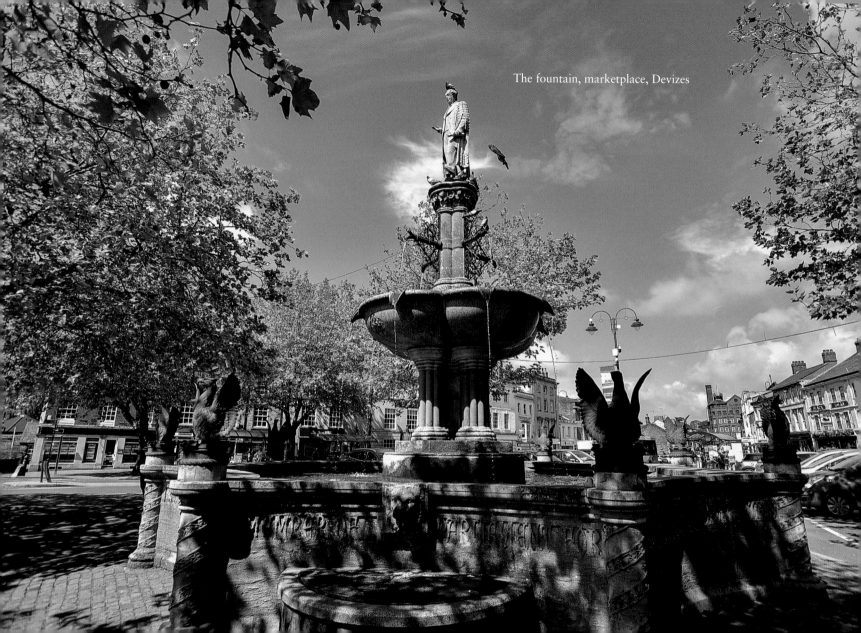

The fountain, marketplace, Devizes

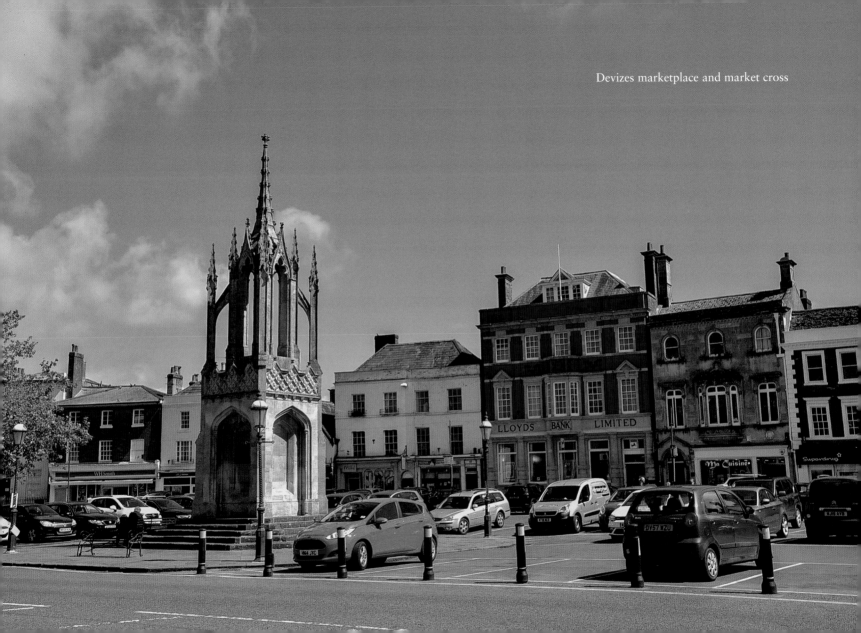

Devizes marketplace and market cross

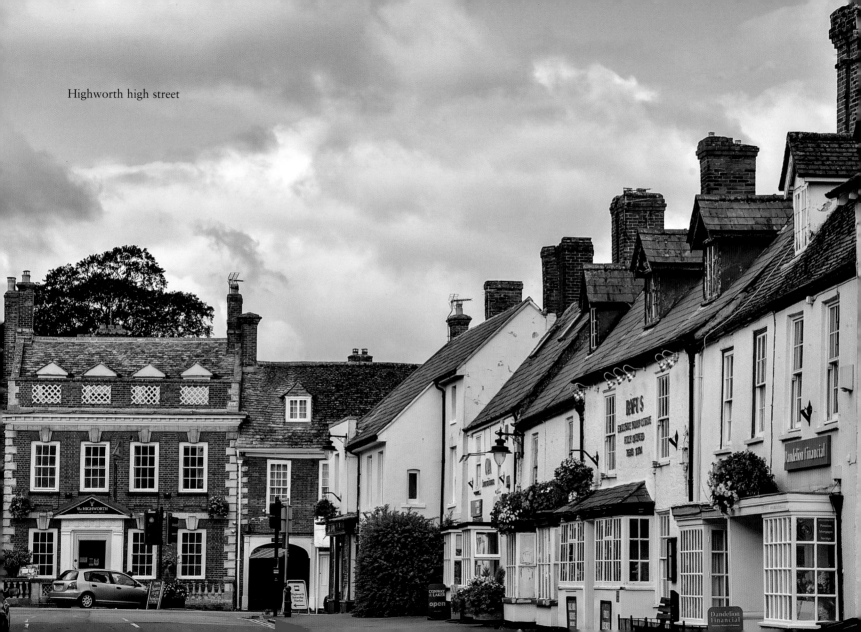

Highworth high street

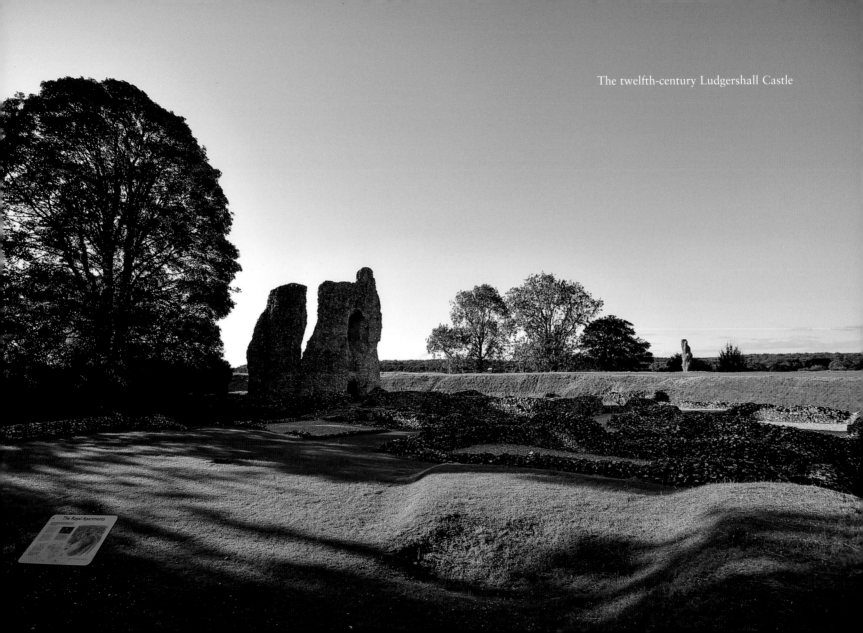

The twelfth-century Ludgershall Castle

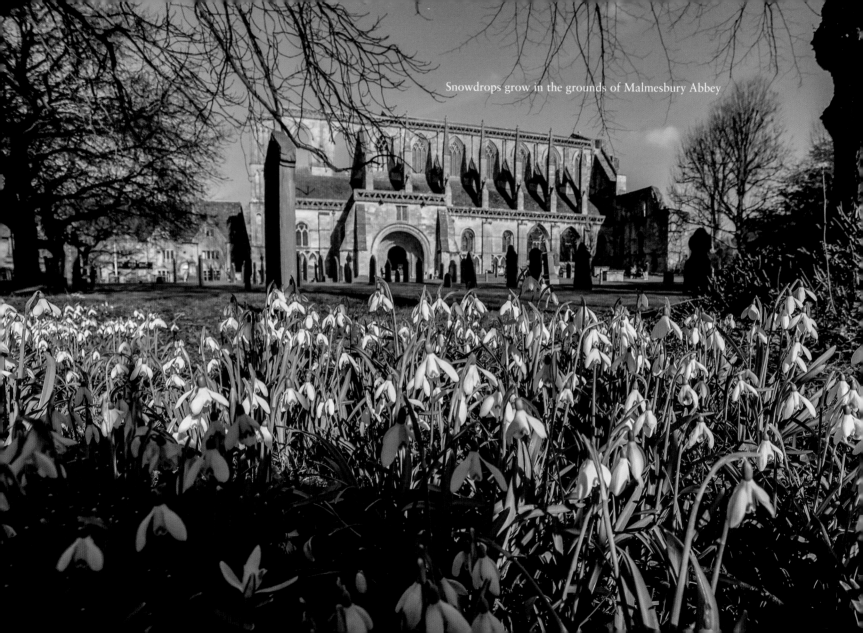

Snowdrops grow in the grounds of Malmesbury Abbey

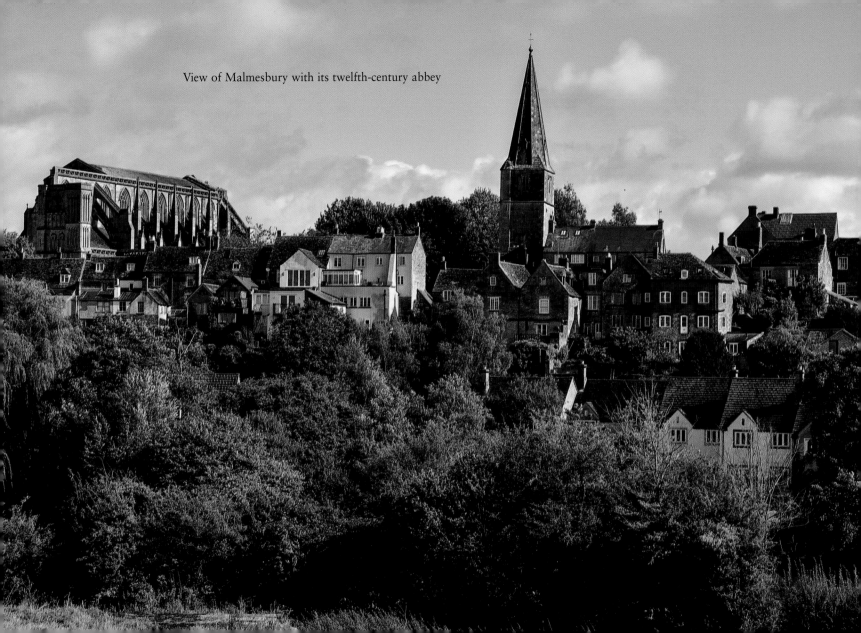

View of Malmesbury with its twelfth-century abbey

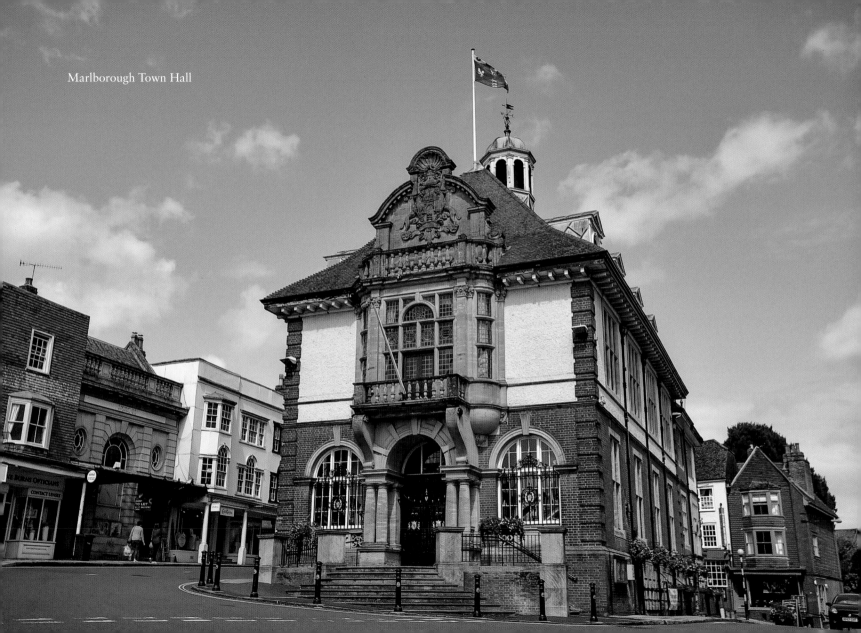
Marlborough Town Hall

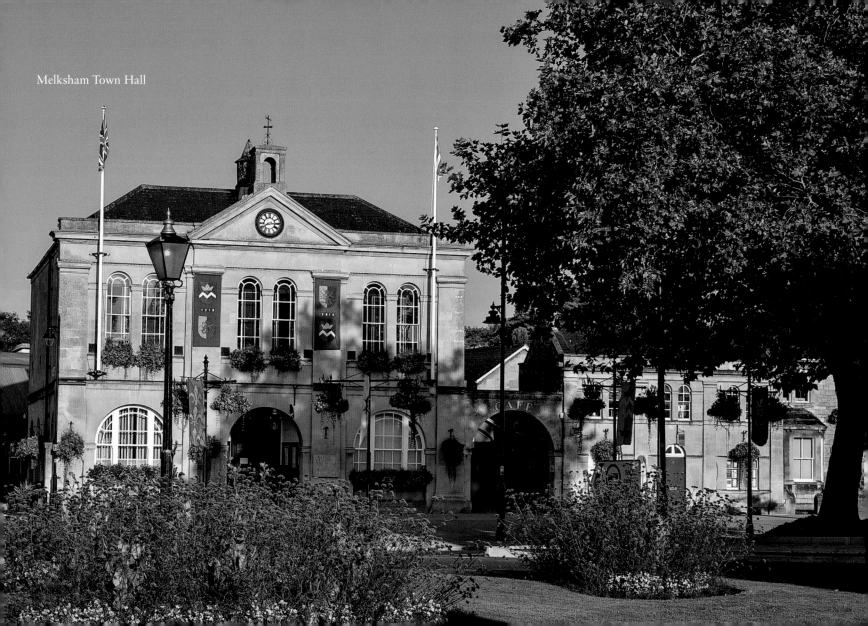

Melksham Town Hall

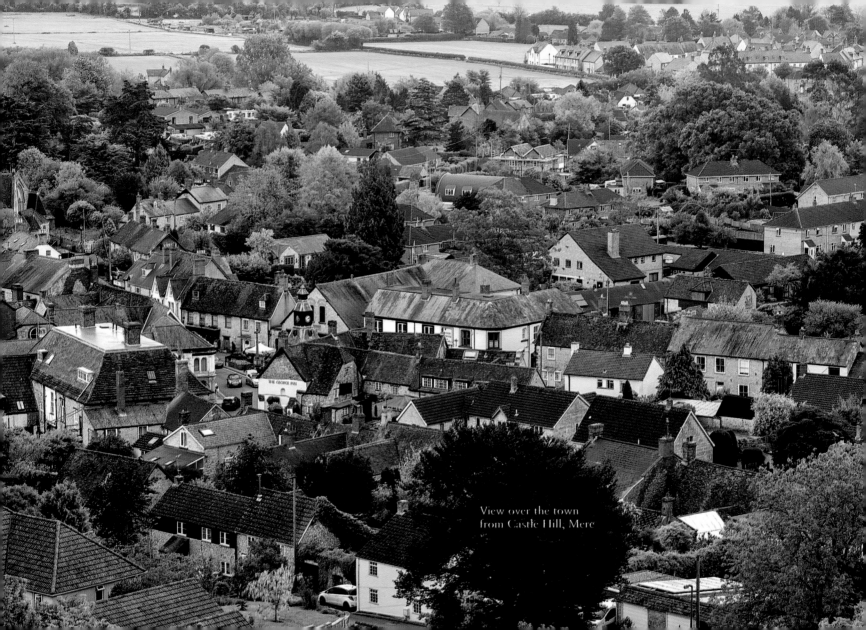

View over the town
from Castle Hill, Mere

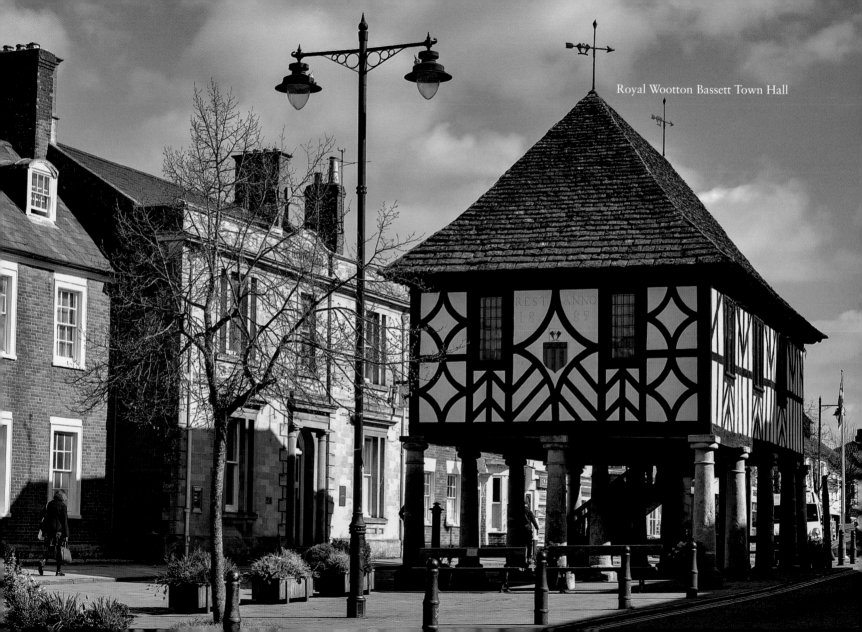
Royal Wootton Bassett Town Hall

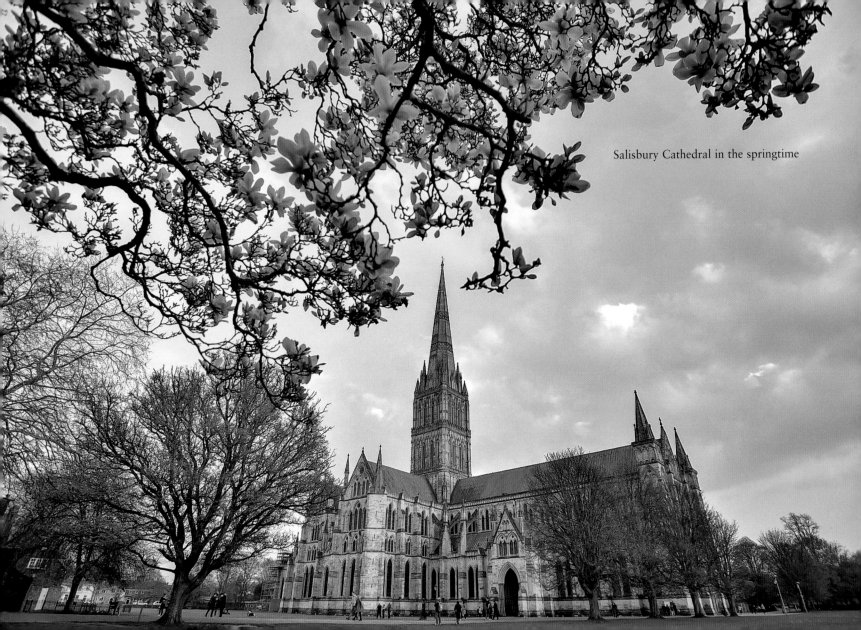

Salisbury Cathedral in the springtime

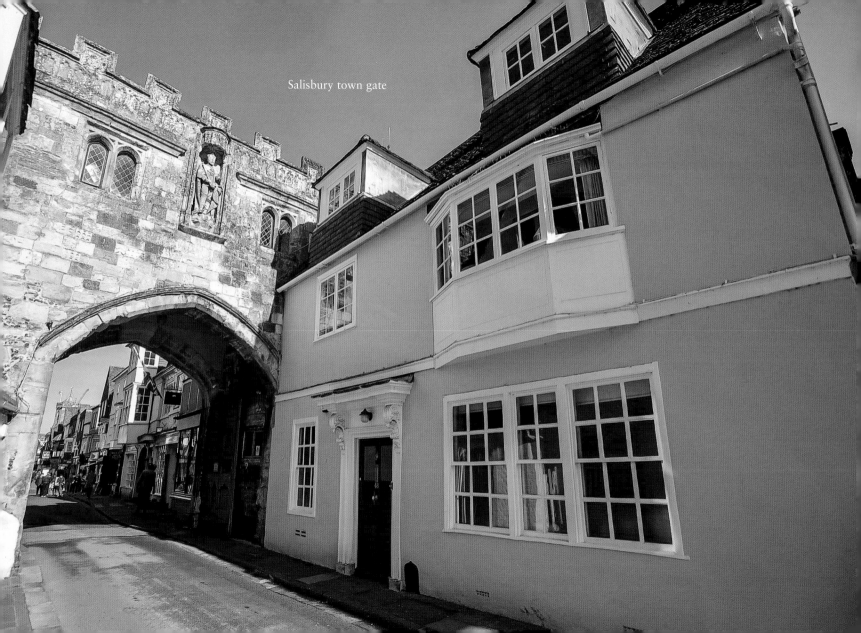

Salisbury town gate

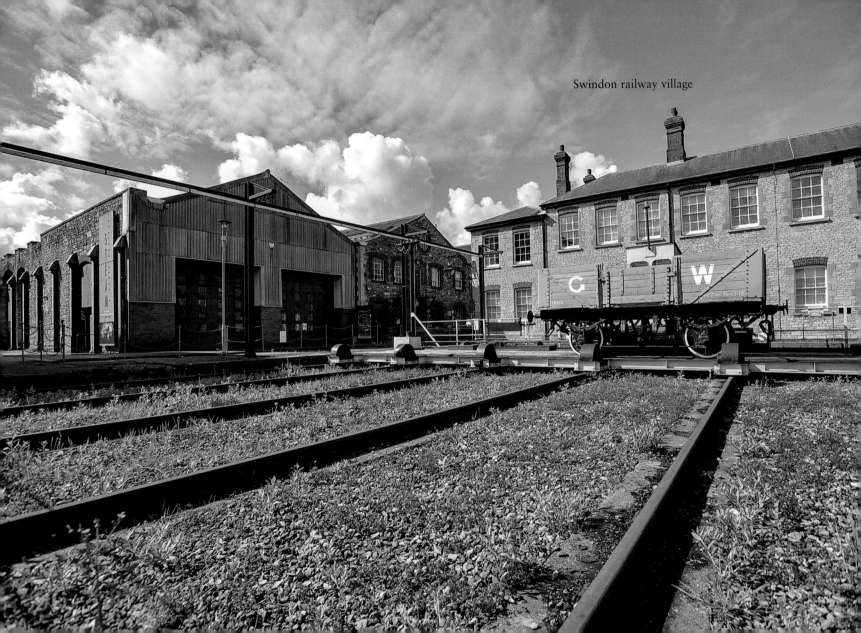

Swindon railway village

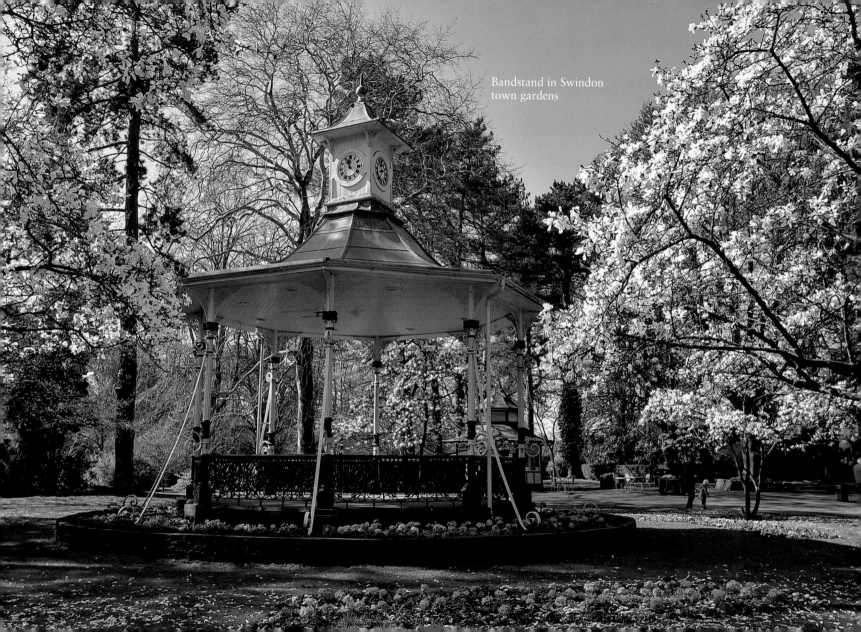

Bandstand in Swindon
town gardens

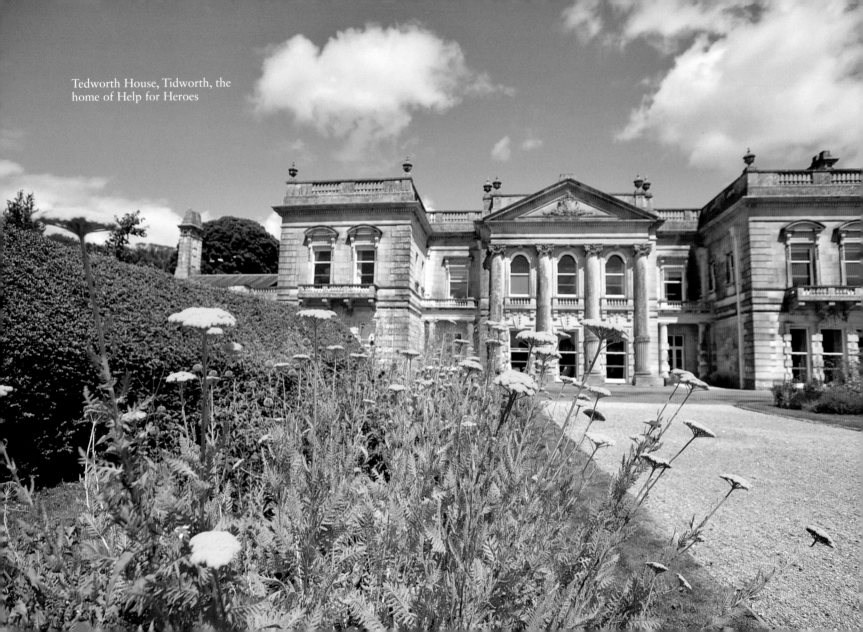

Tedworth House, Tidworth, the home of Help for Heroes

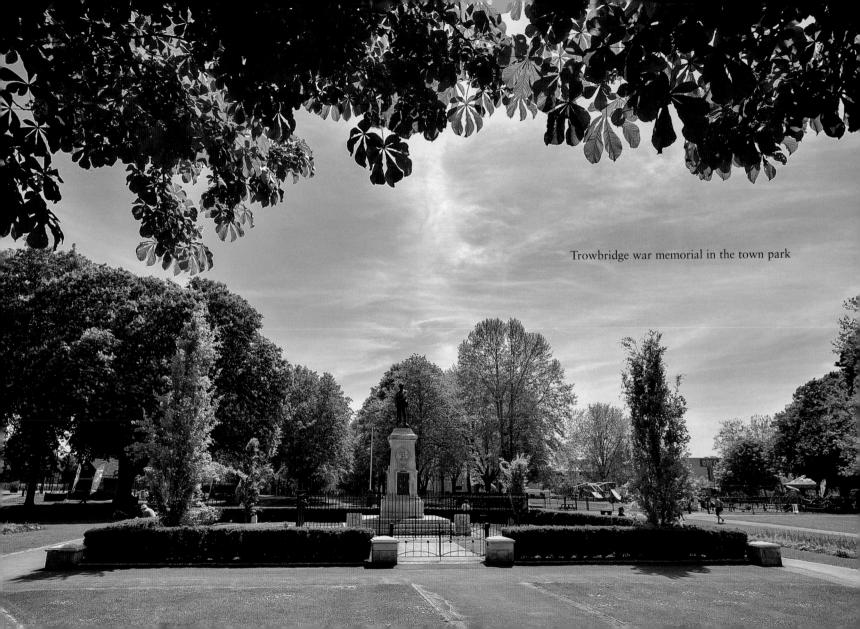

Trowbridge war memorial in the town park

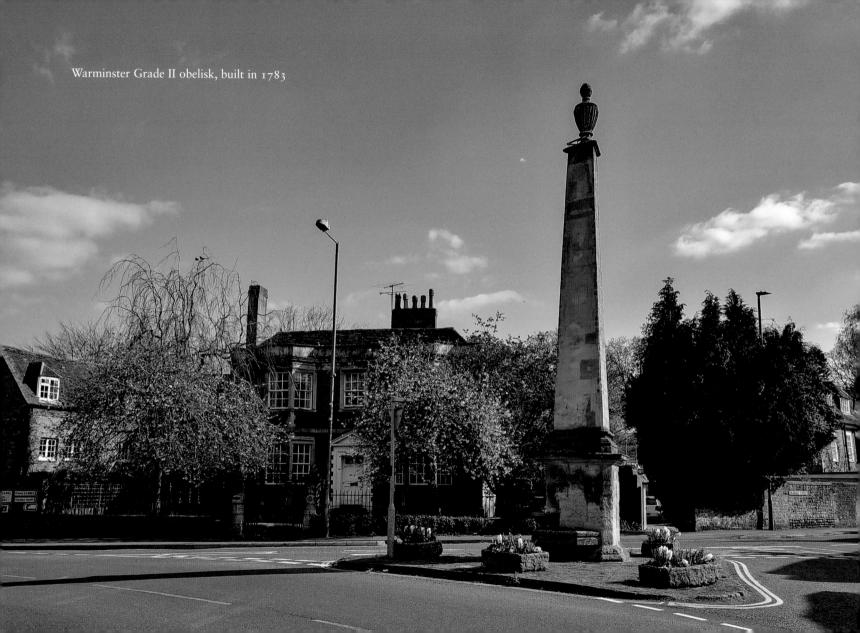

Warminster Grade II obelisk, built in 1783

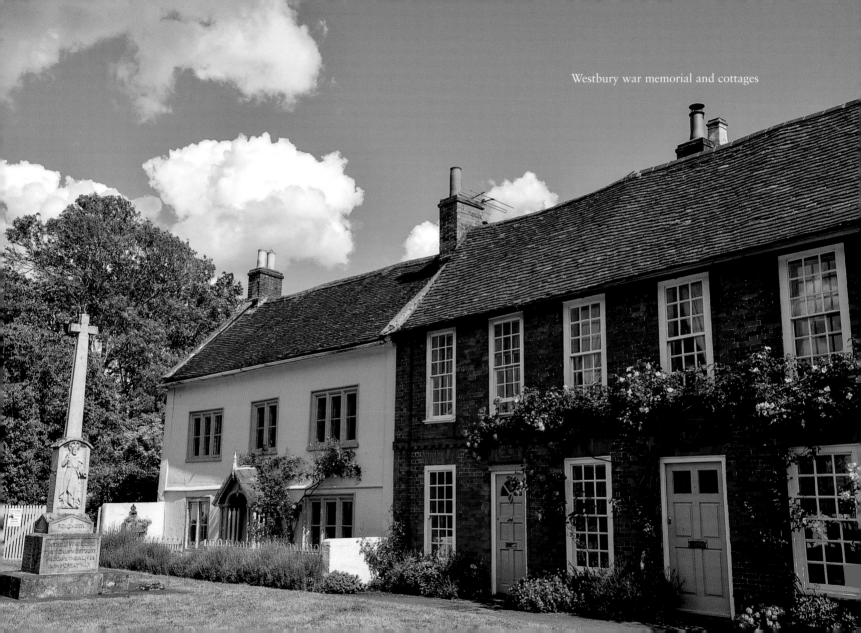

Westbury war memorial and cottages

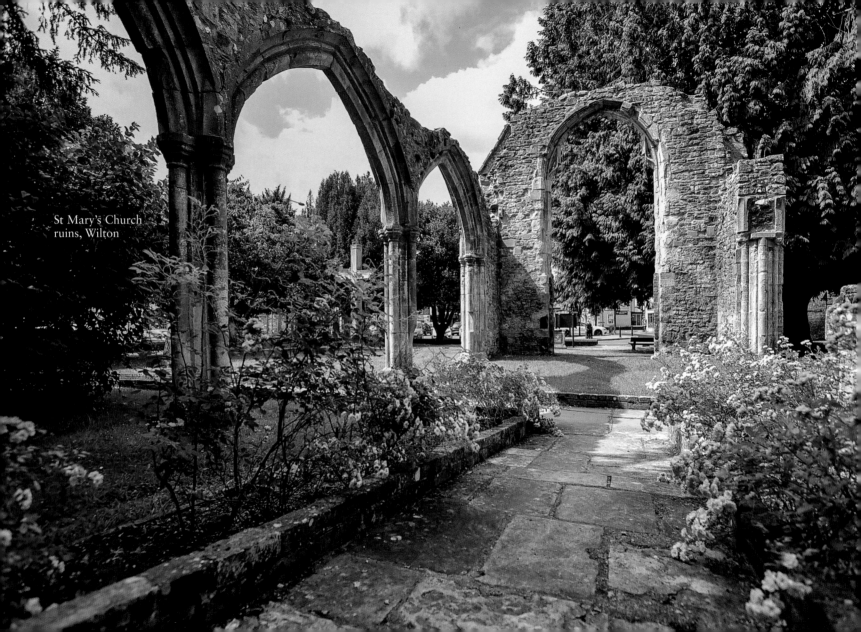

St Mary's Church
ruins, Wilton

VILLAGES

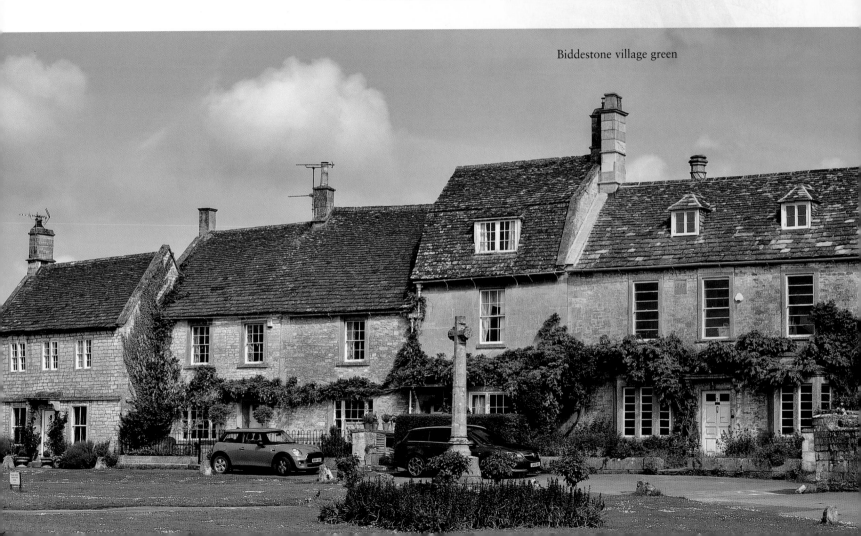

Biddestone village green

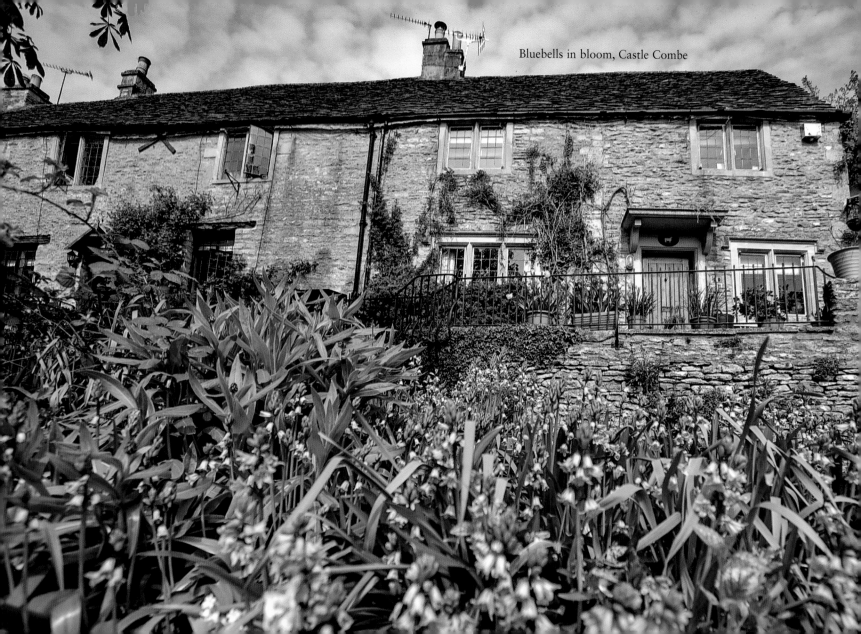

Bluebells in bloom, Castle Combe

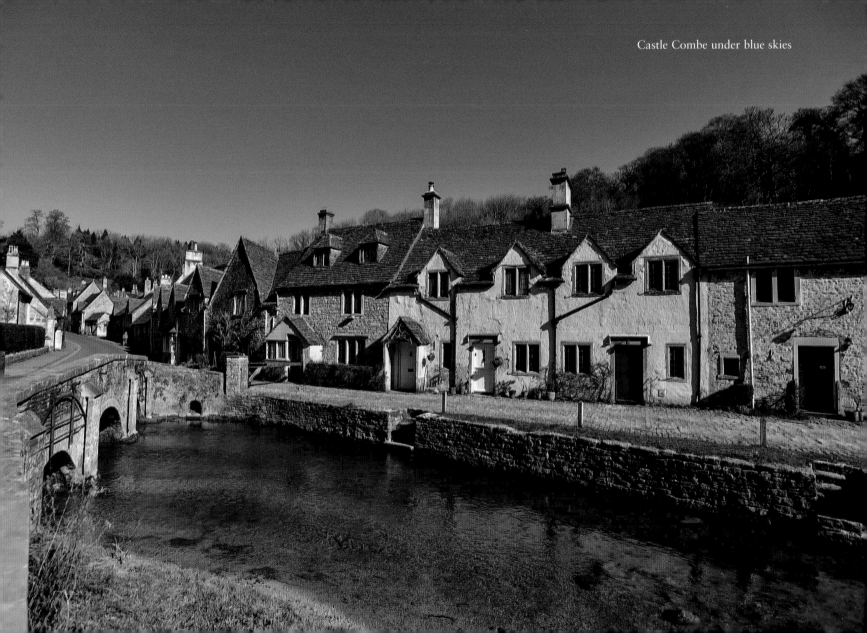
Castle Combe under blue skies

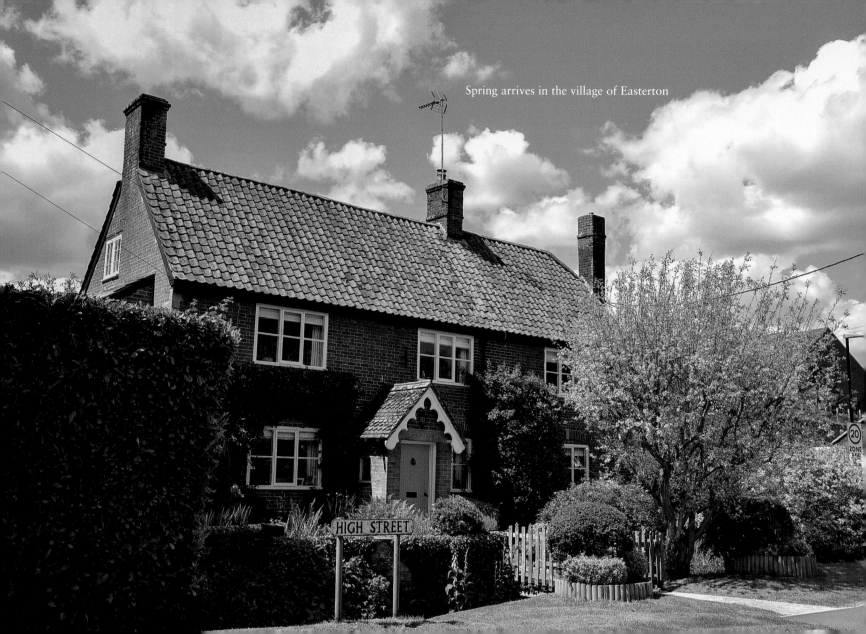
Spring arrives in the village of Easterton

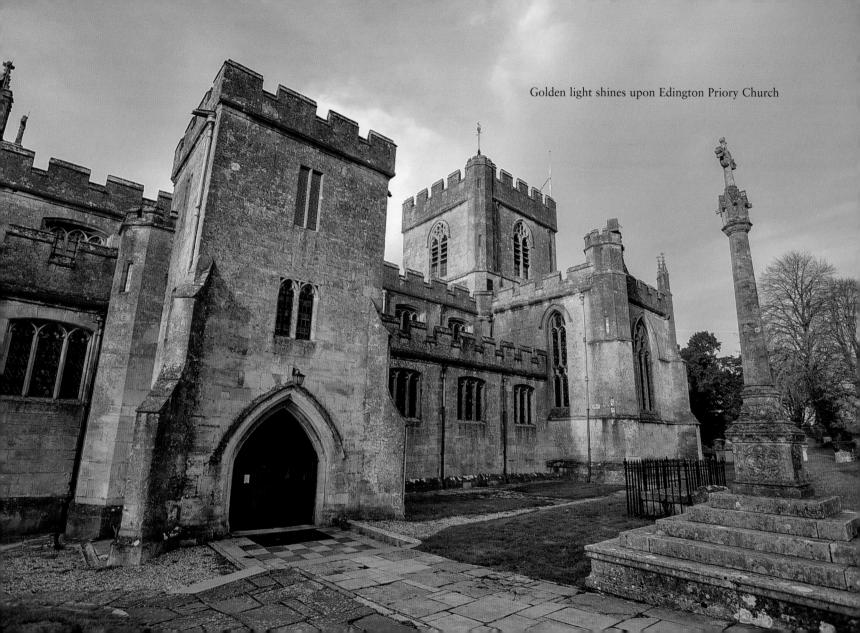

Golden light shines upon Edington Priory Church

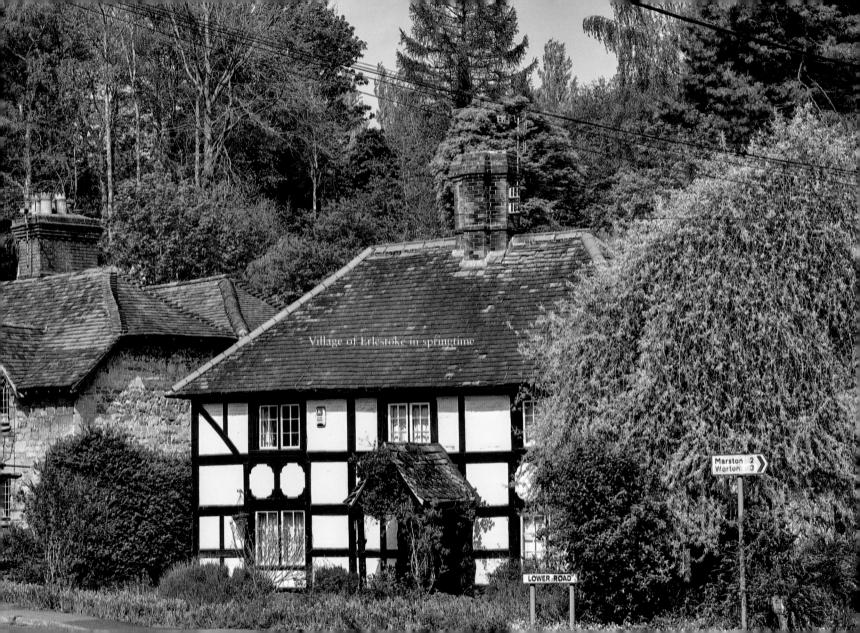

Village of Erlestoke in springtime

Marston 2
Worton 3

LOWER ROAD

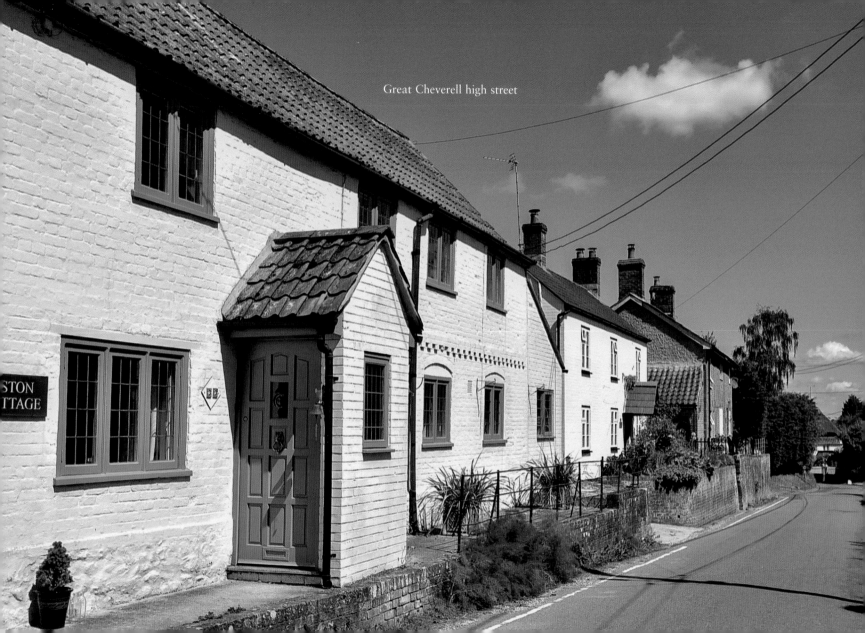

Great Cheverell high street

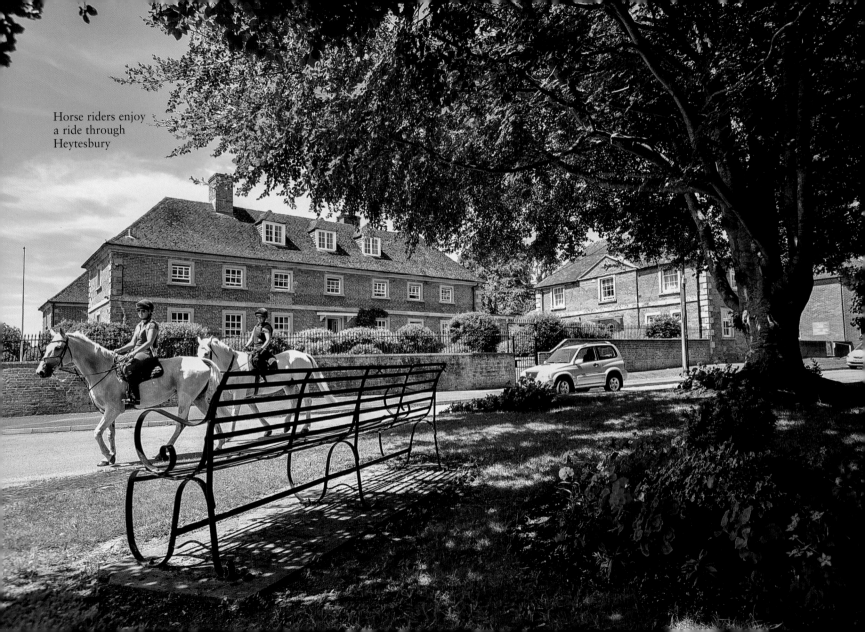

Horse riders enjoy
a ride through
Heytesbury

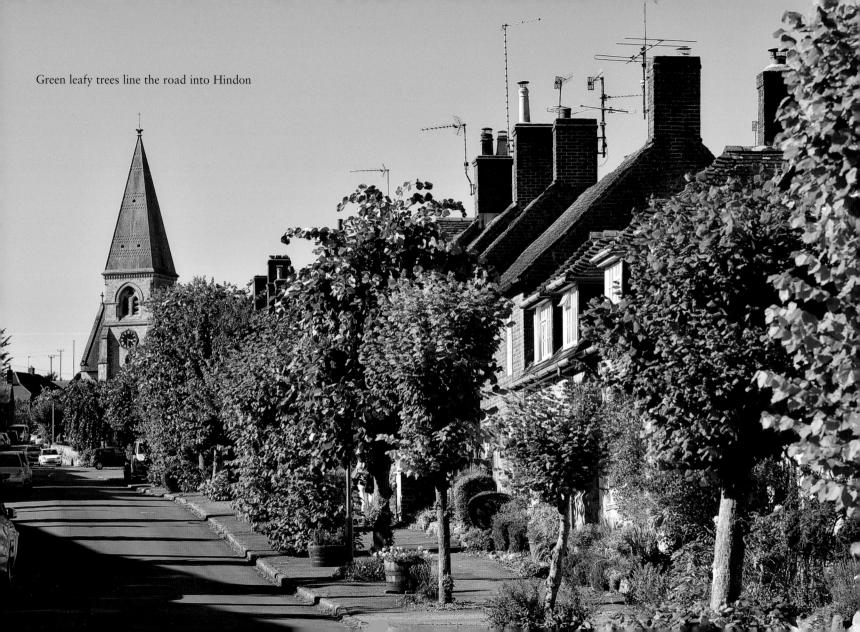

Green leafy trees line the road into Hindon

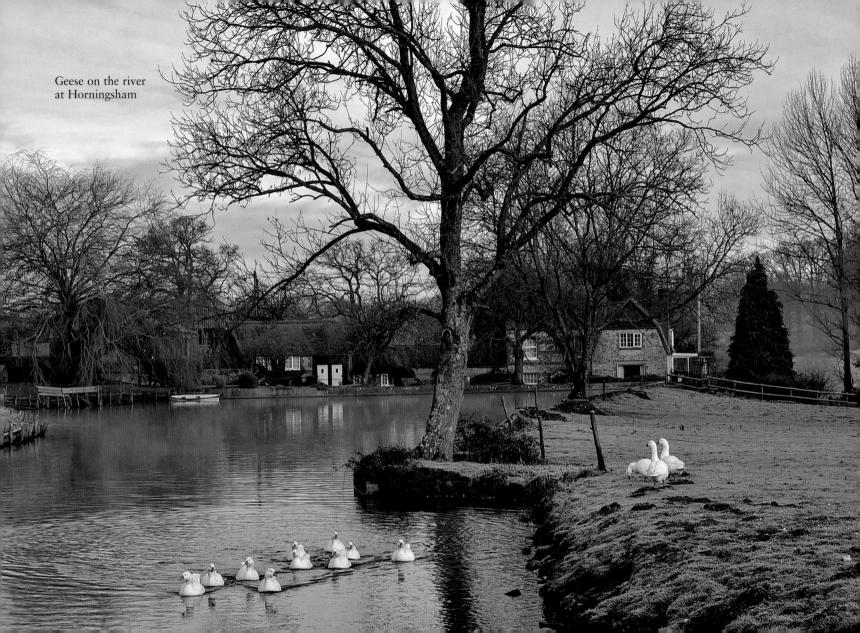

Geese on the river
at Horningsham

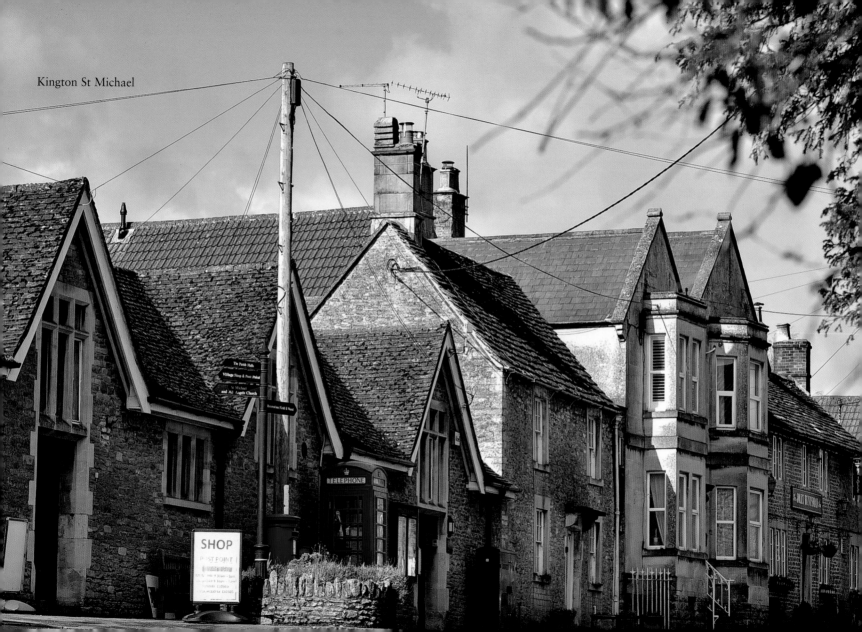

Kington St Michael

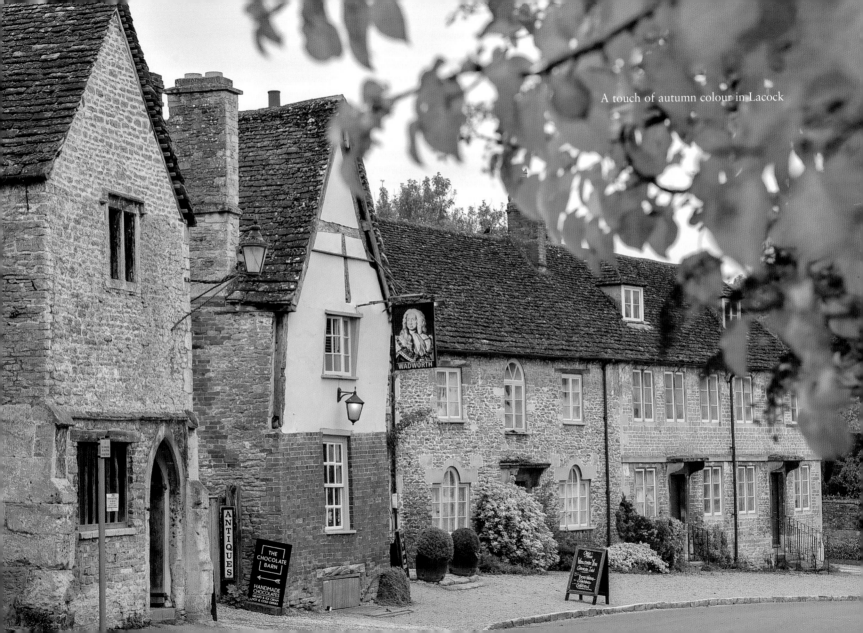

A touch of autumn colour in Lacock

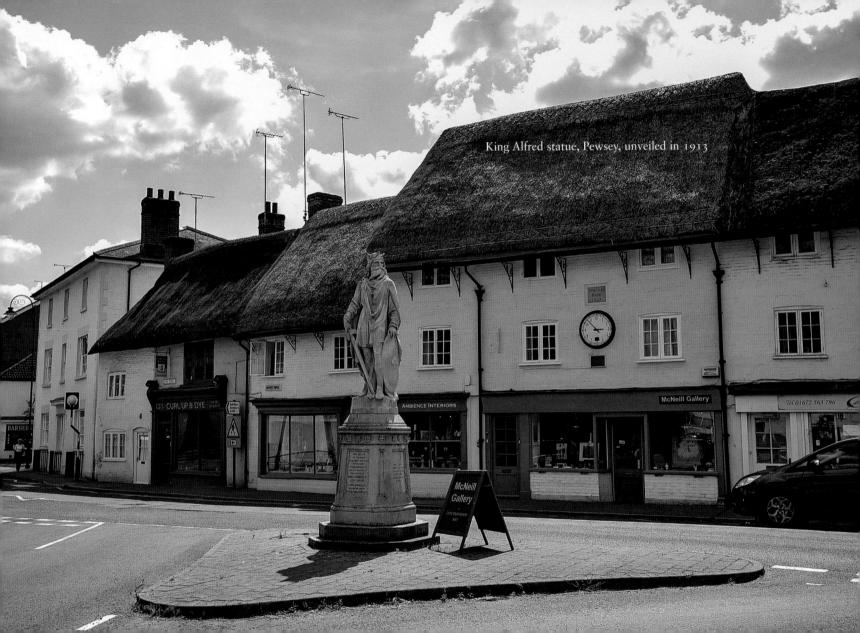

King Alfred statue, Pewsey, unveiled in 1913

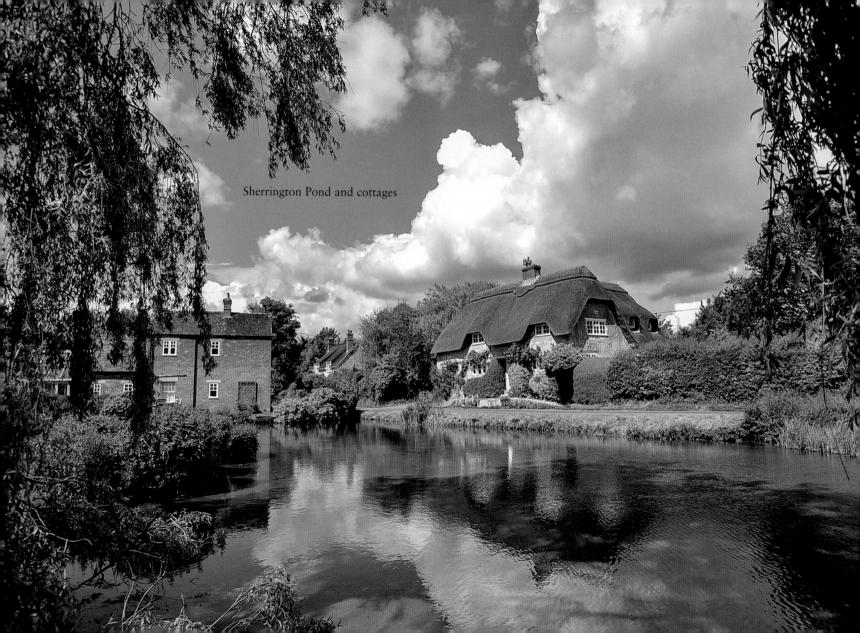

Sherrington Pond and cottages

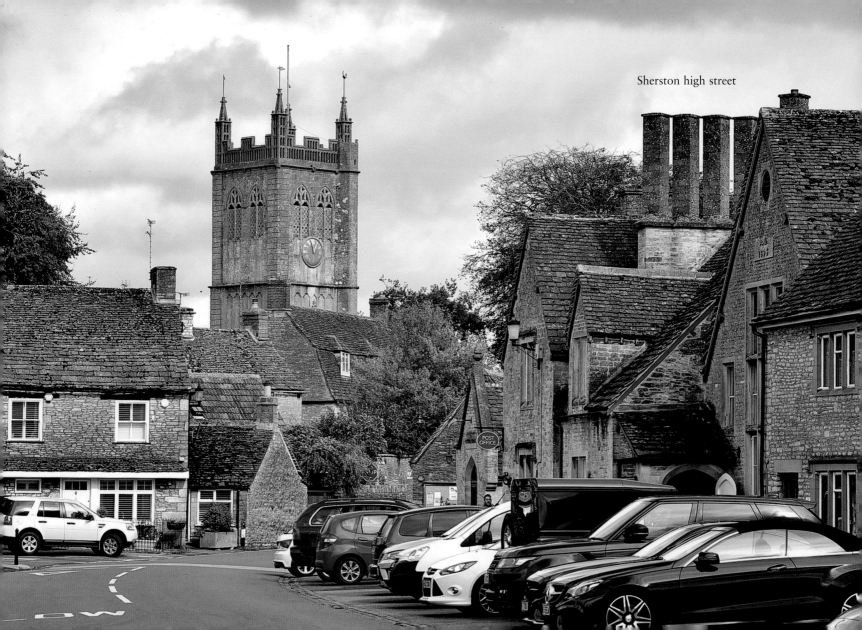

Sherston high street

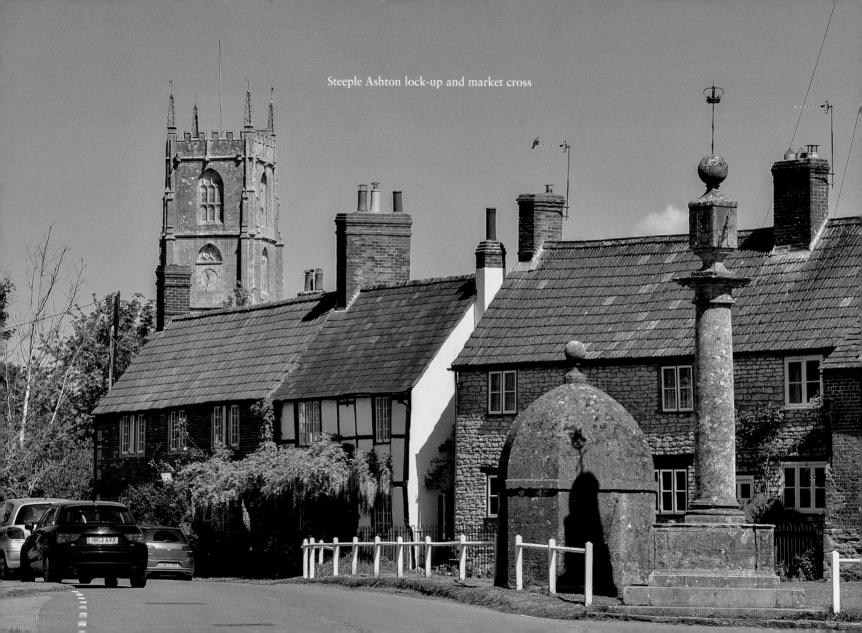

Steeple Ashton lock-up and market cross

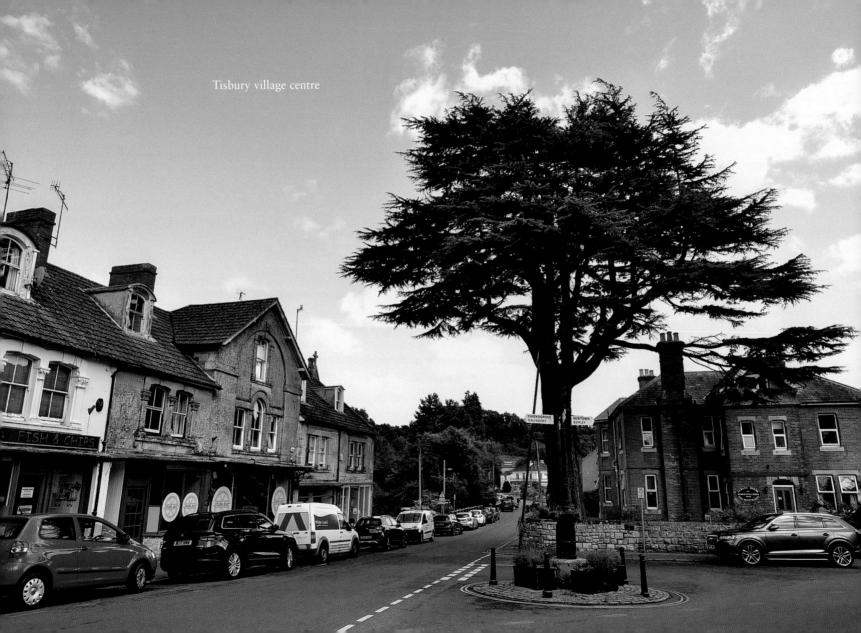

Tisbury village centre

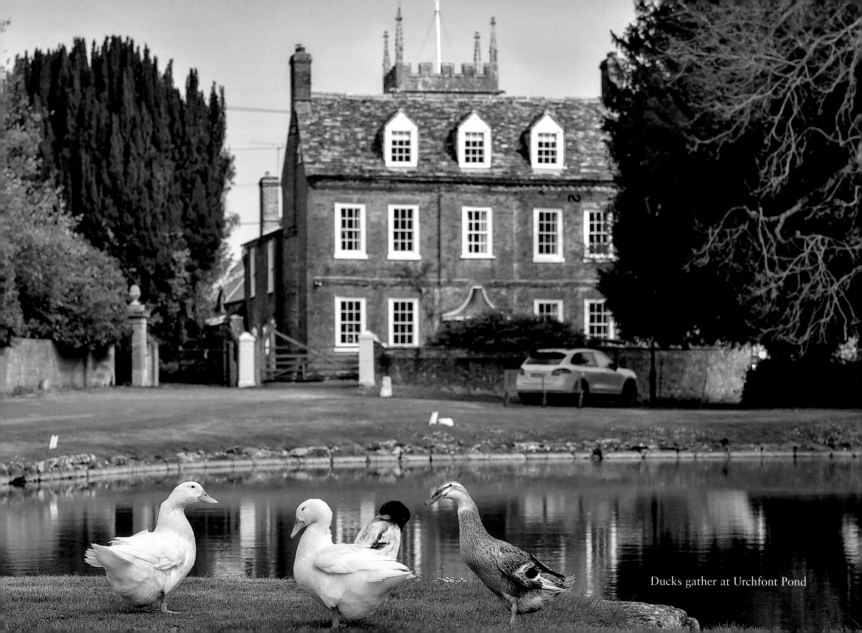

Ducks gather at Urchfont Pond

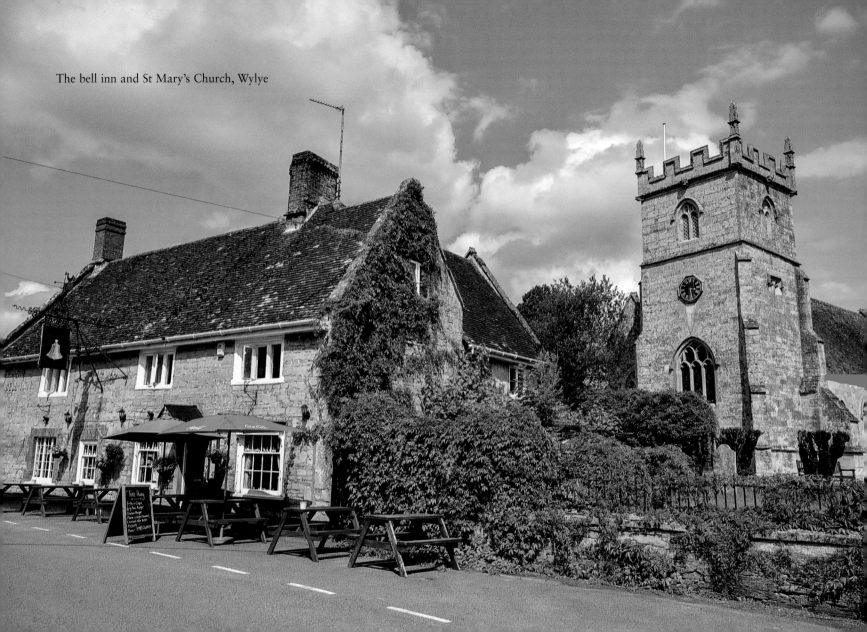

The bell inn and St Mary's Church, Wylye

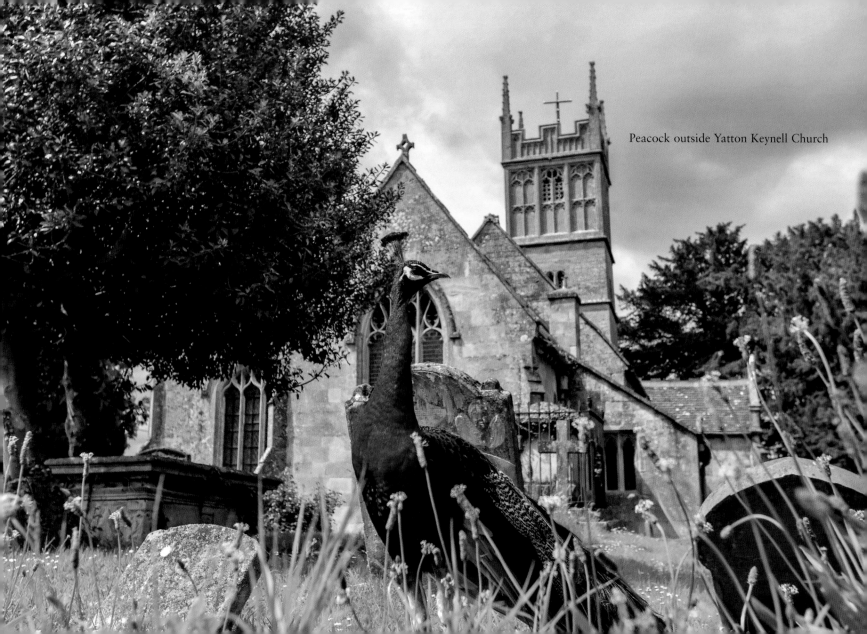

Peacock outside Yatton Keynell Church

WILTSHIRE LANDSCAPES

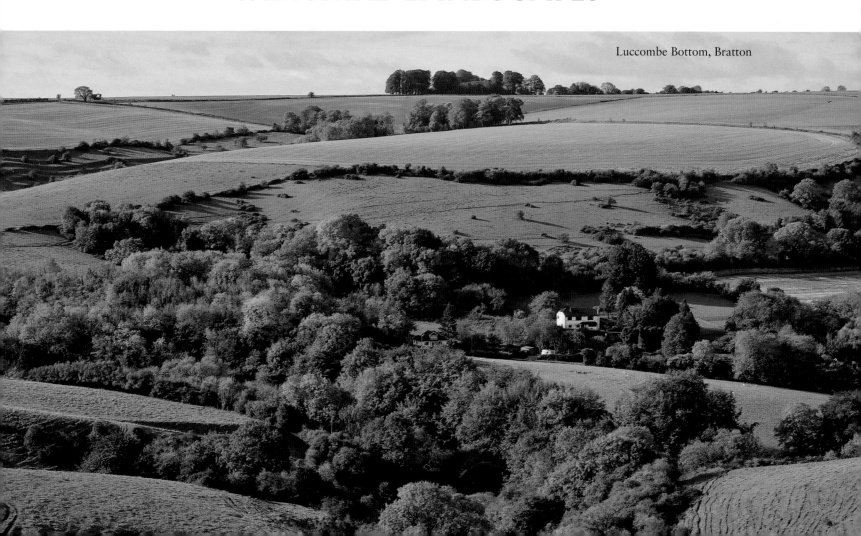

Luccombe Bottom, Bratton

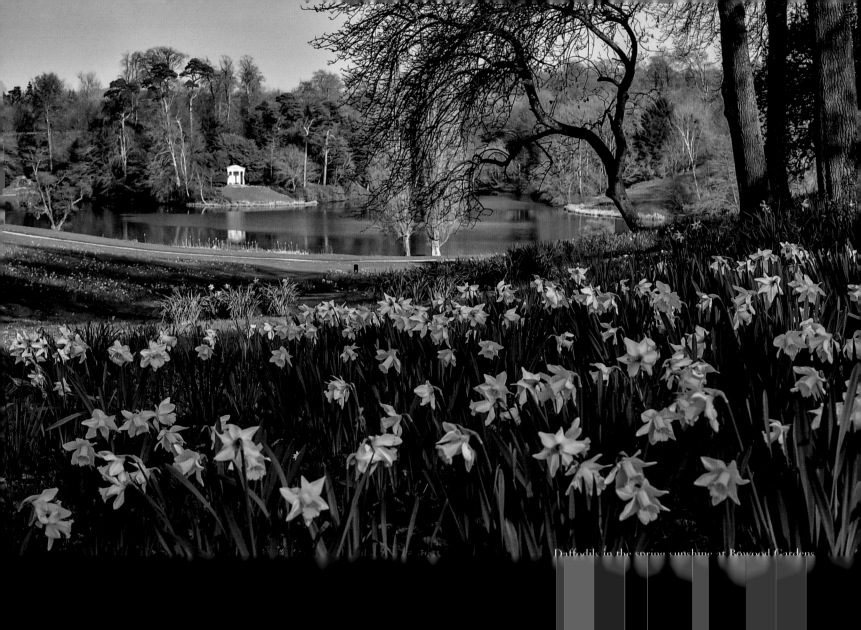

Daffodils in the spring sunshine at Bowood Gardens

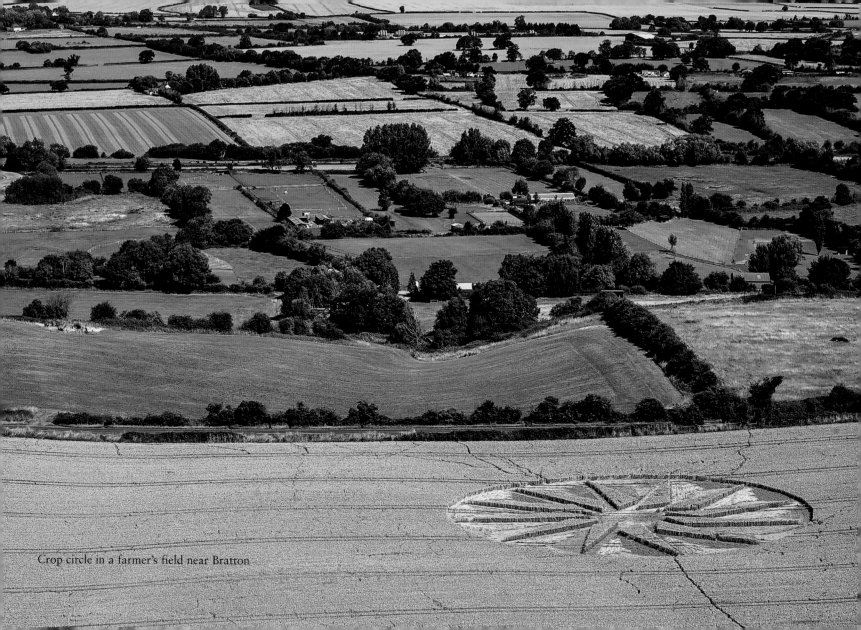

Crop circle in a farmer's field near Bratton

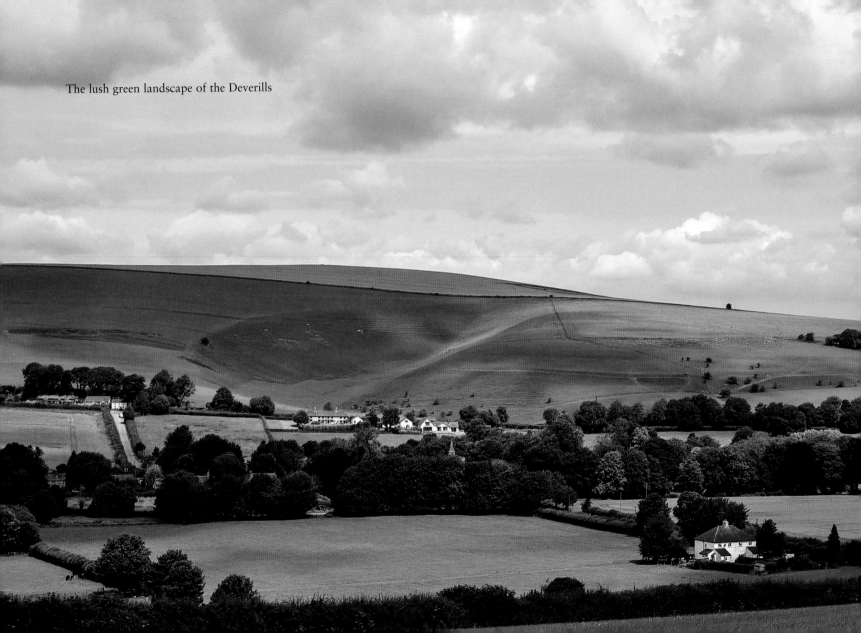

The lush green landscape of the Deverills

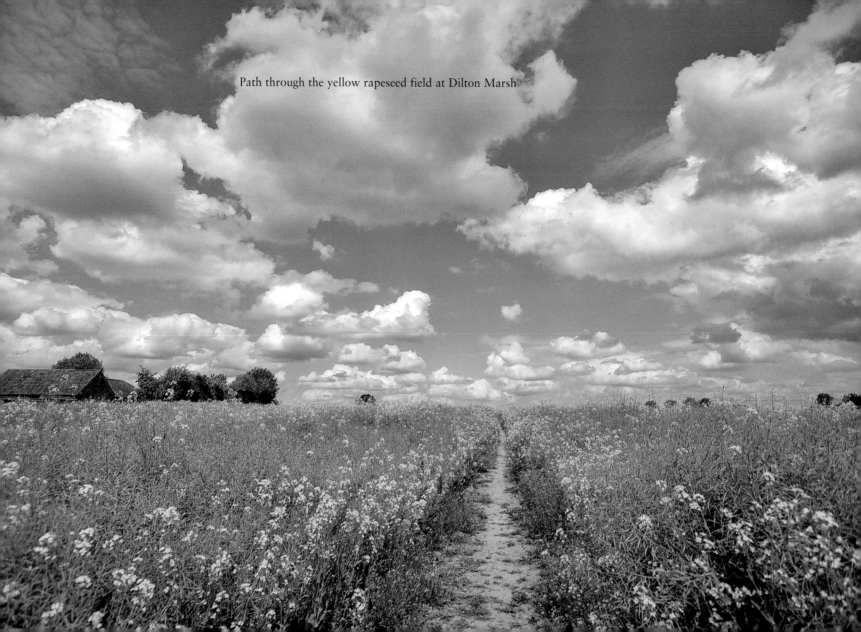

Path through the yellow rapeseed field at Dilton Marsh

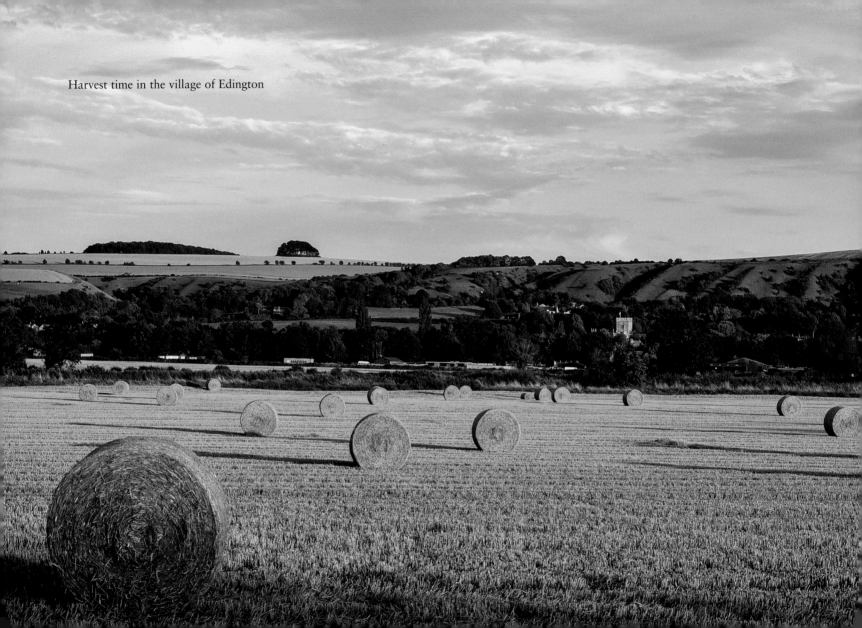
Harvest time in the village of Edington

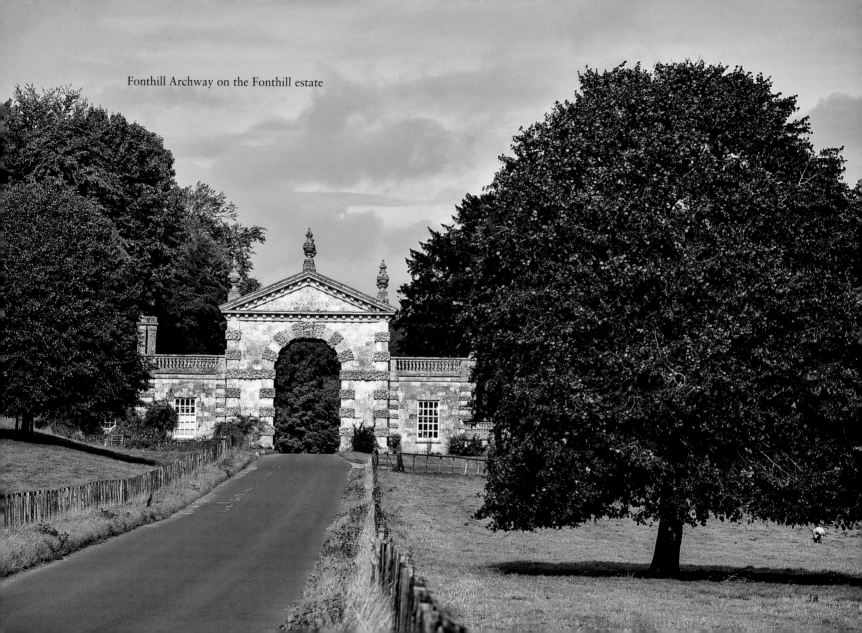

Fonthill Archway on the Fonthill estate

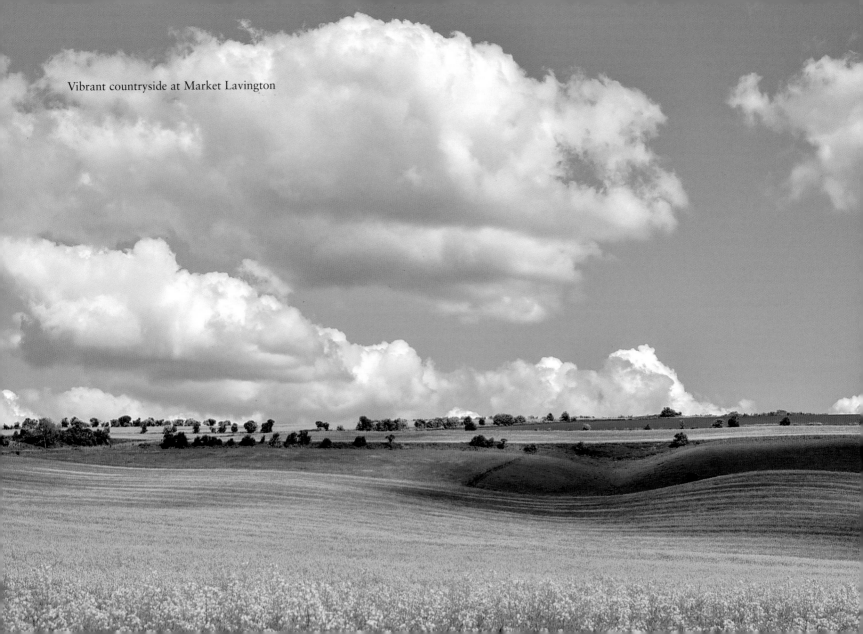
Vibrant countryside at Market Lavington

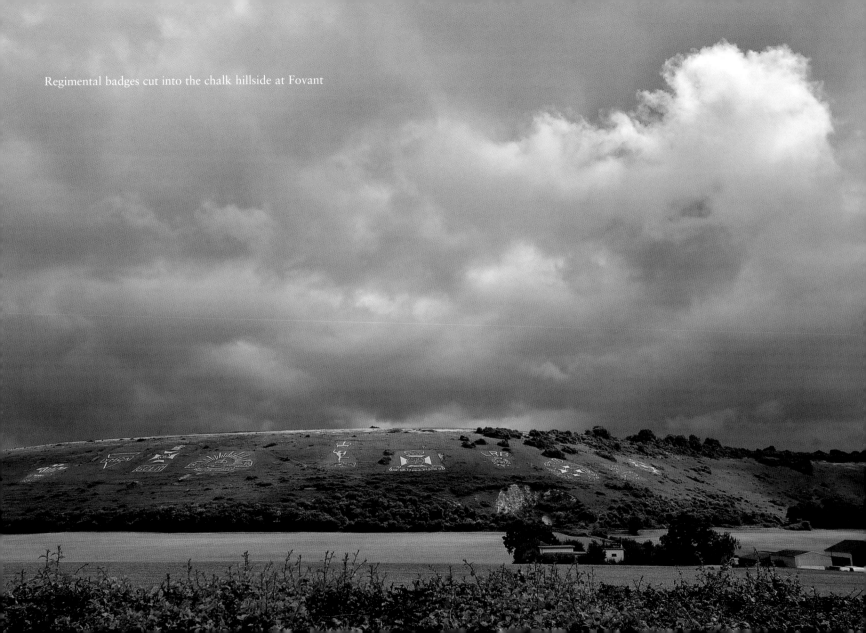

Regimental badges cut into the chalk hillside at Fovant

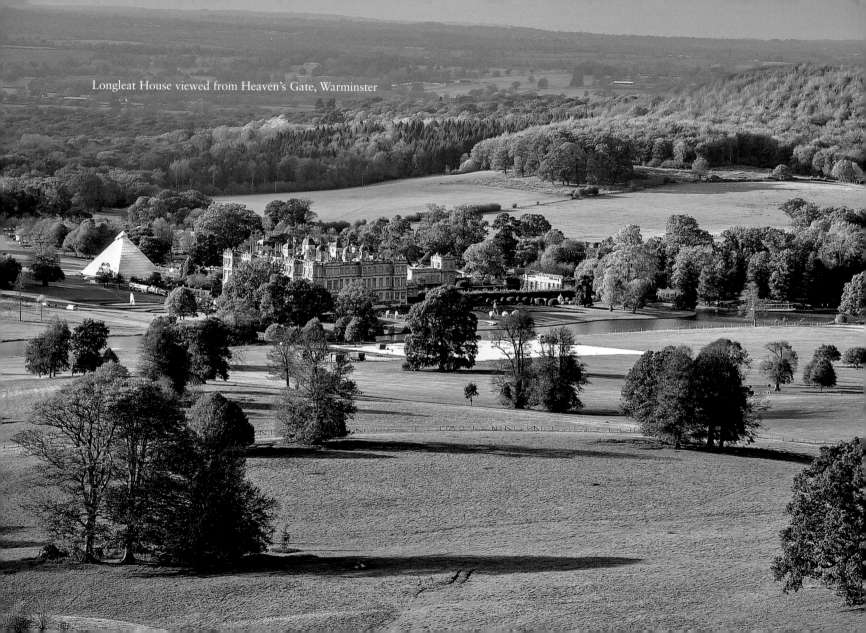
Longleat House viewed from Heaven's Gate, Warminster

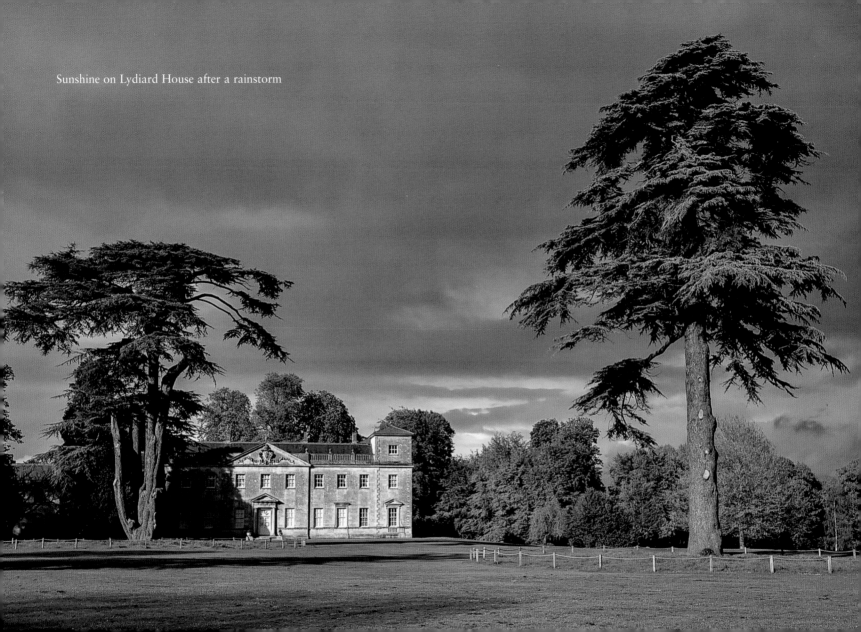
Sunshine on Lydiard House after a rainstorm

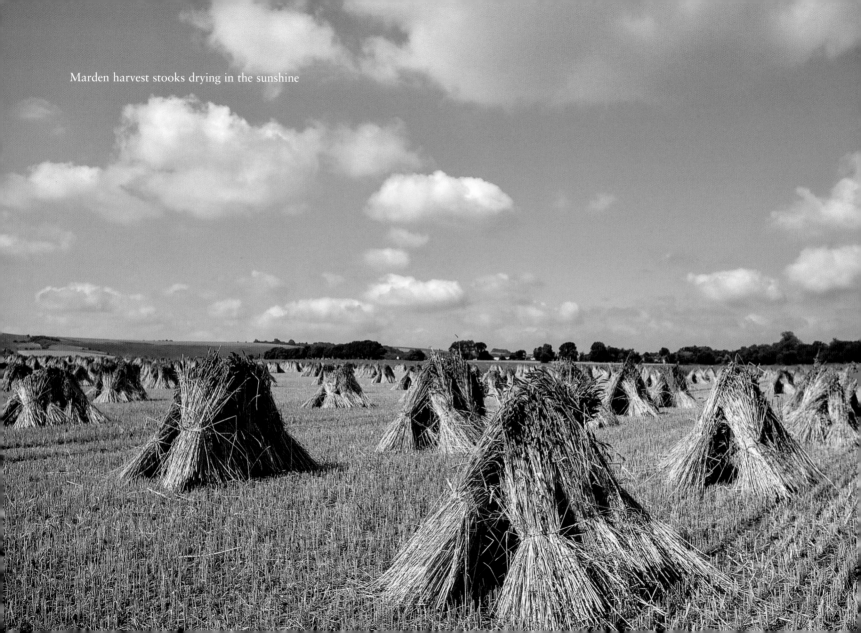

Marden harvest stooks drying in the sunshine

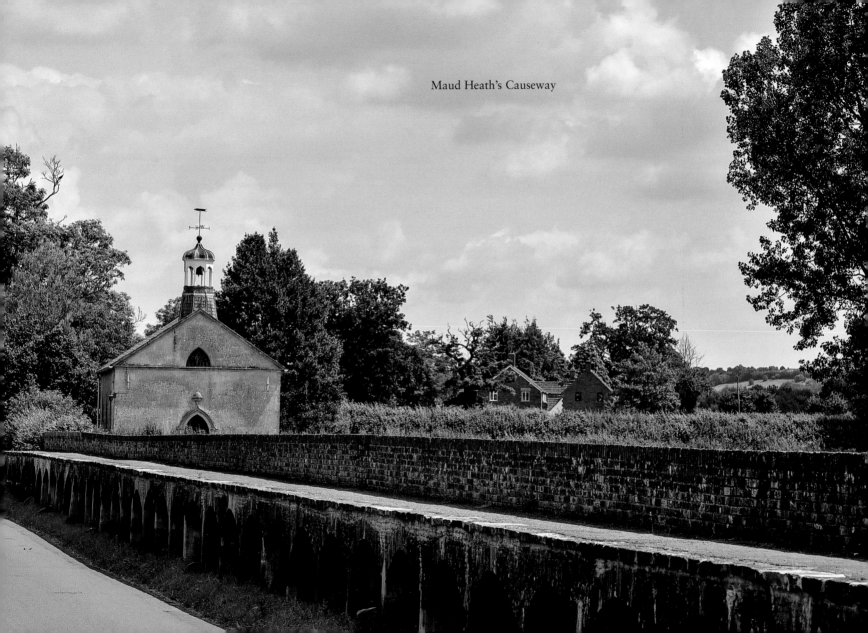

Maud Heath's Causeway

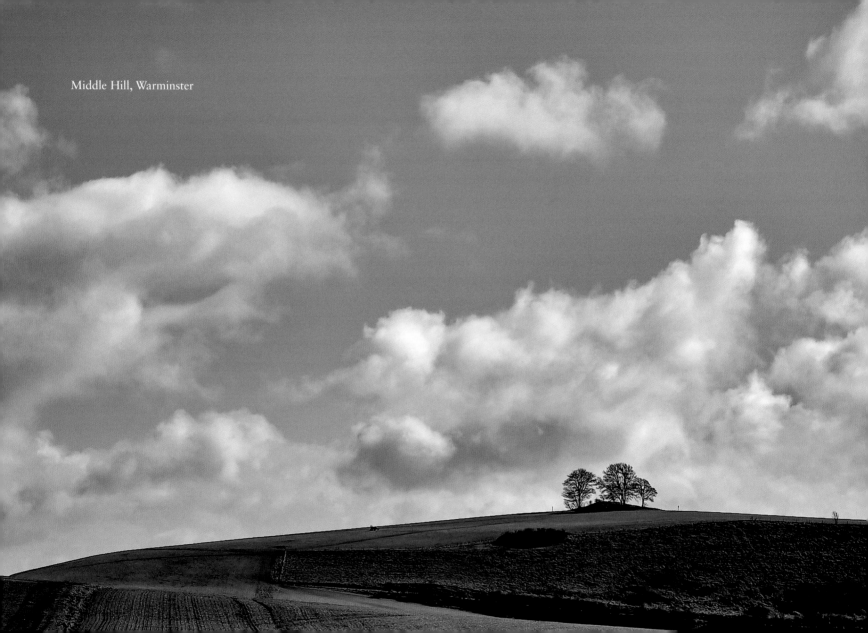

Middle Hill, Warminster

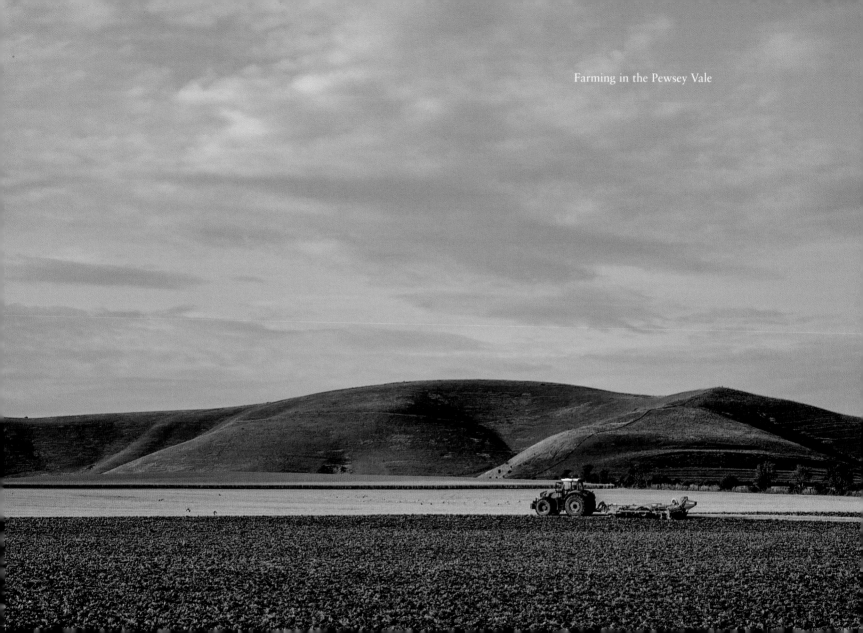

Farming in the Pewsey Vale

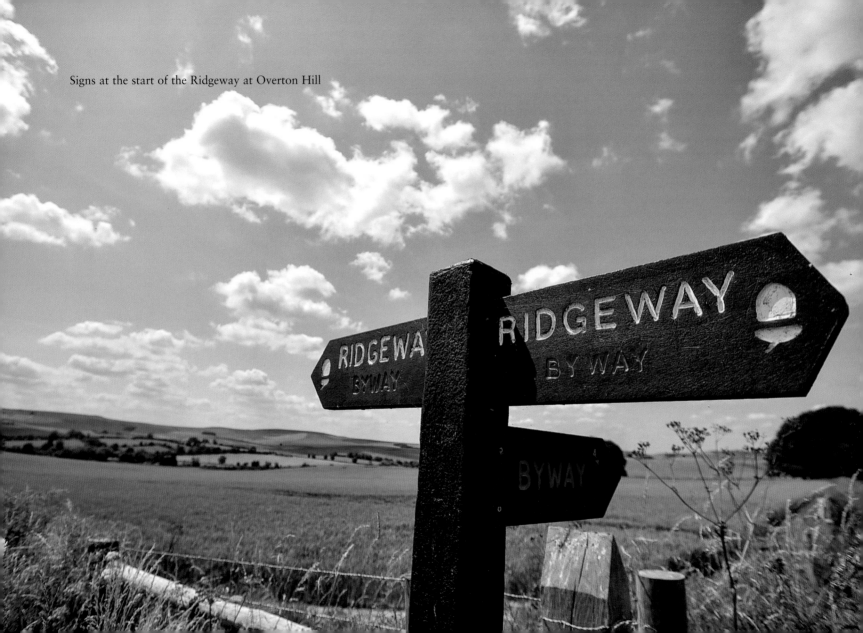

Signs at the start of the Ridgeway at Overton Hill

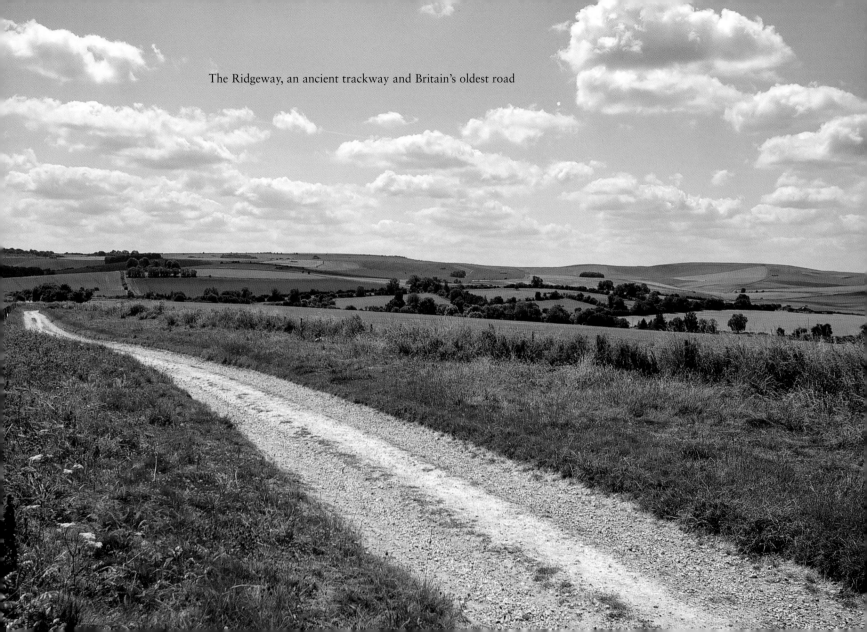

The Ridgeway, an ancient trackway and Britain's oldest road

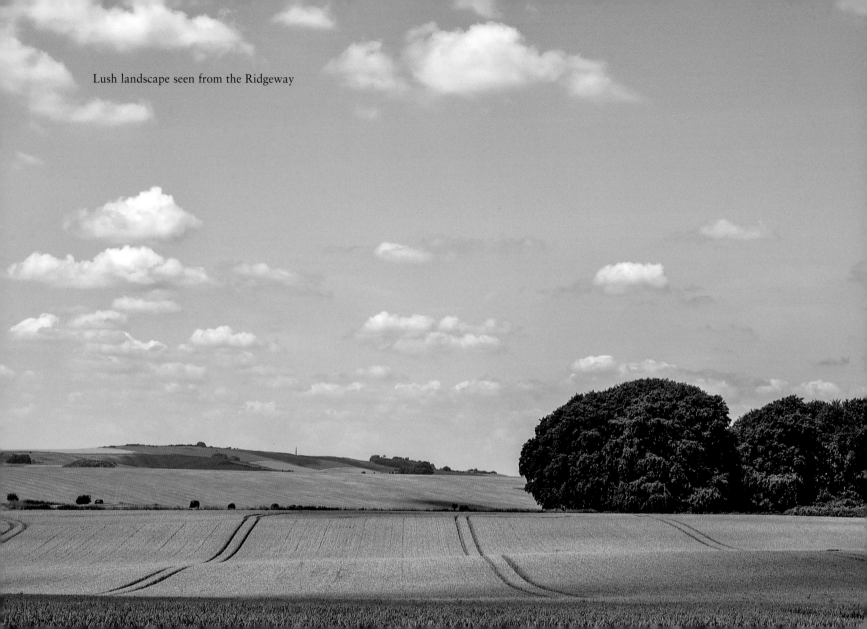

Lush landscape seen from the Ridgeway

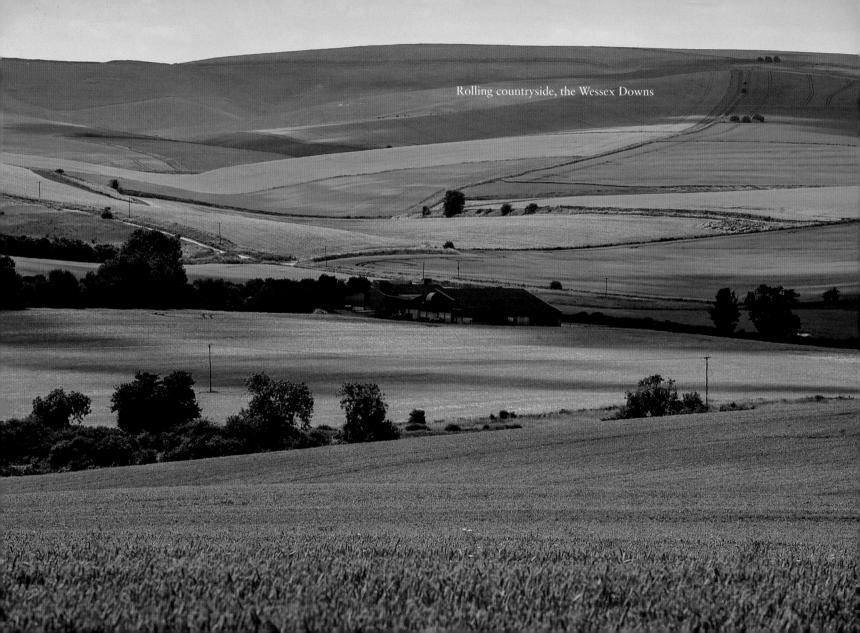

Rolling countryside, the Wessex Downs

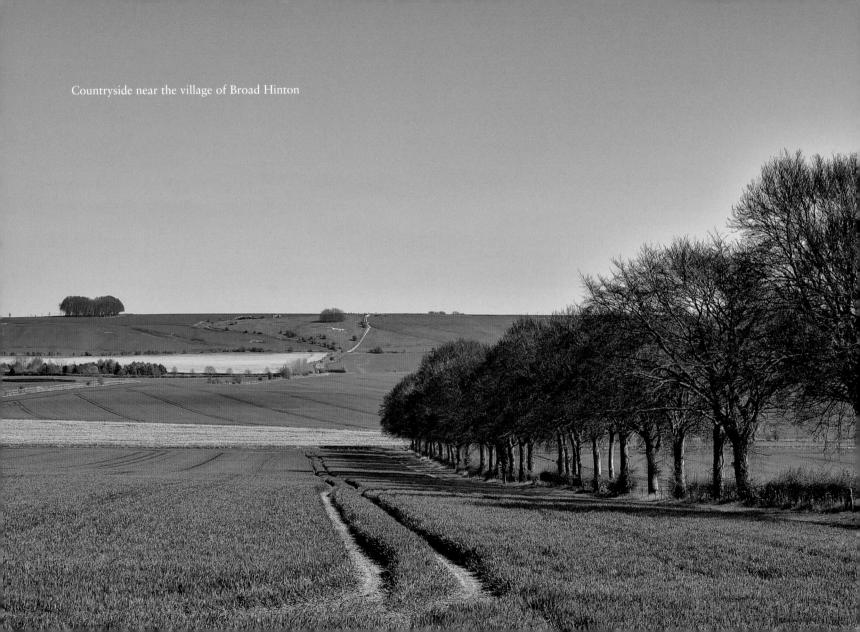

Countryside near the village of Broad Hinton

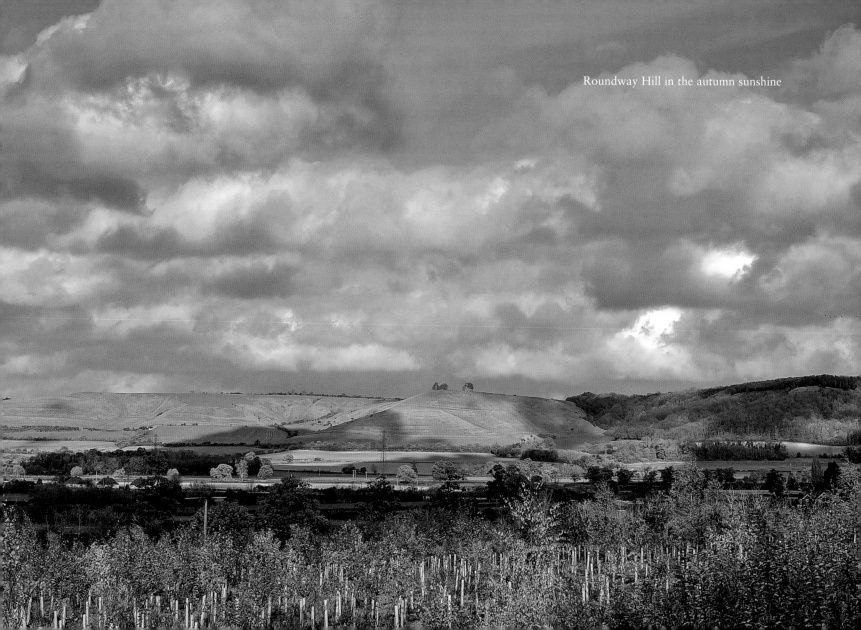

Roundway Hill in the autumn sunshine

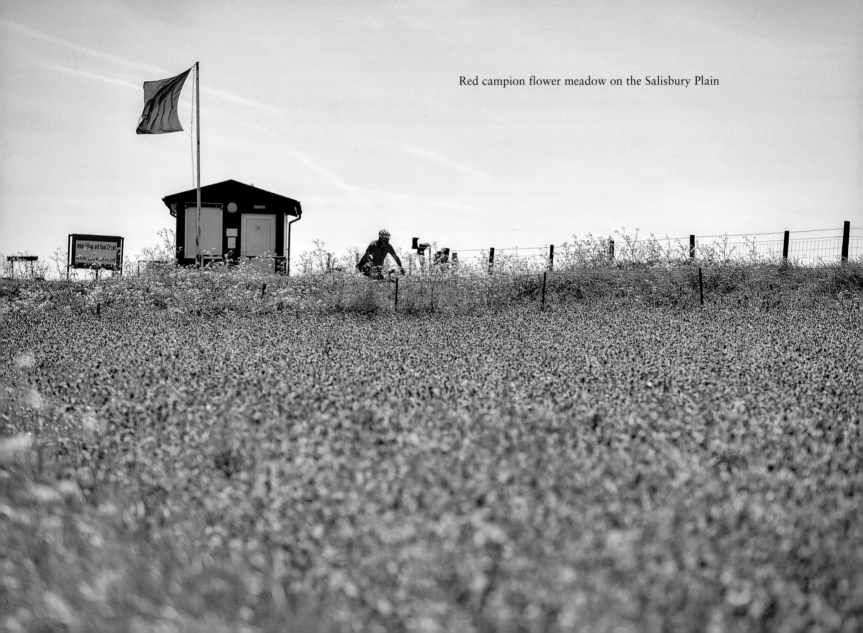

Red campion flower meadow on the Salisbury Plain

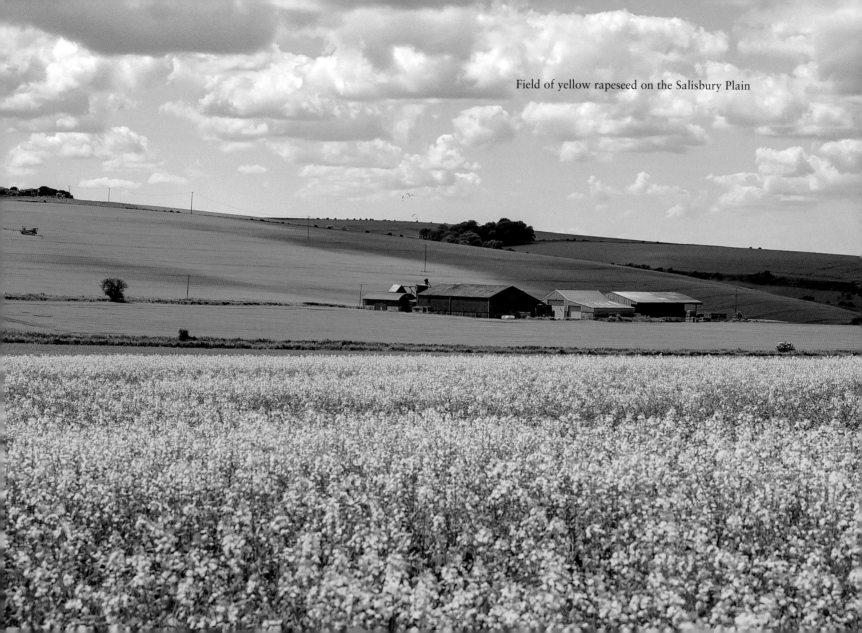

Field of yellow rapeseed on the Salisbury Plain

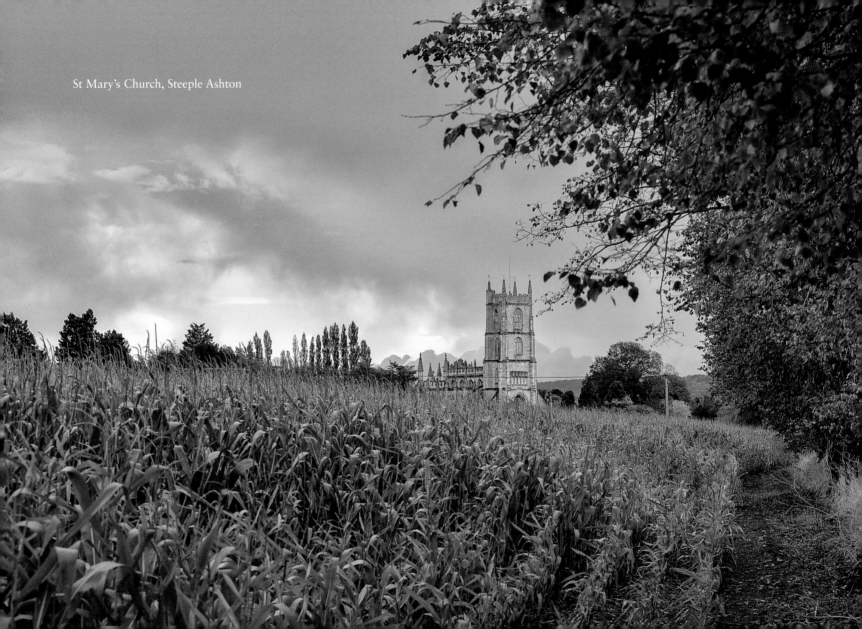

St Mary's Church, Steeple Ashton

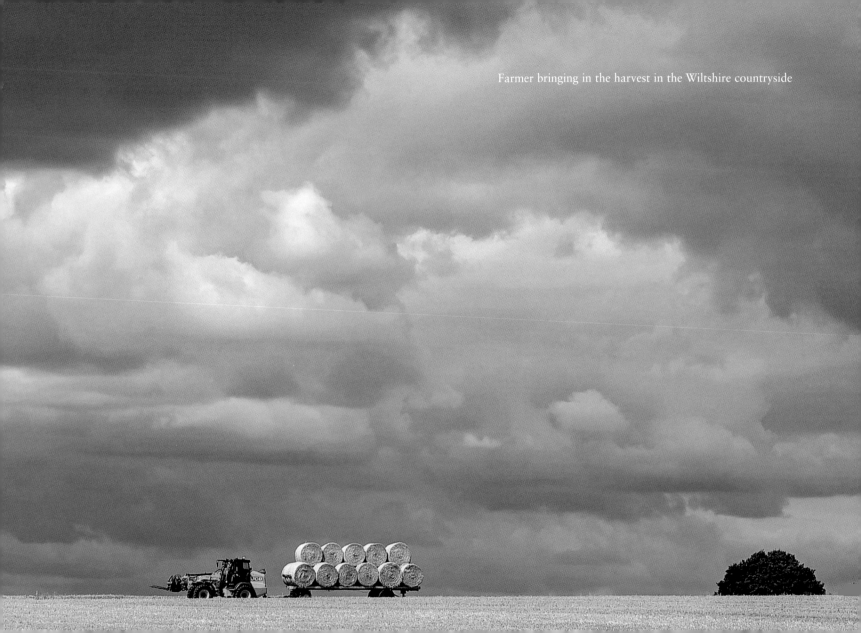

Farmer bringing in the harvest in the Wiltshire countryside

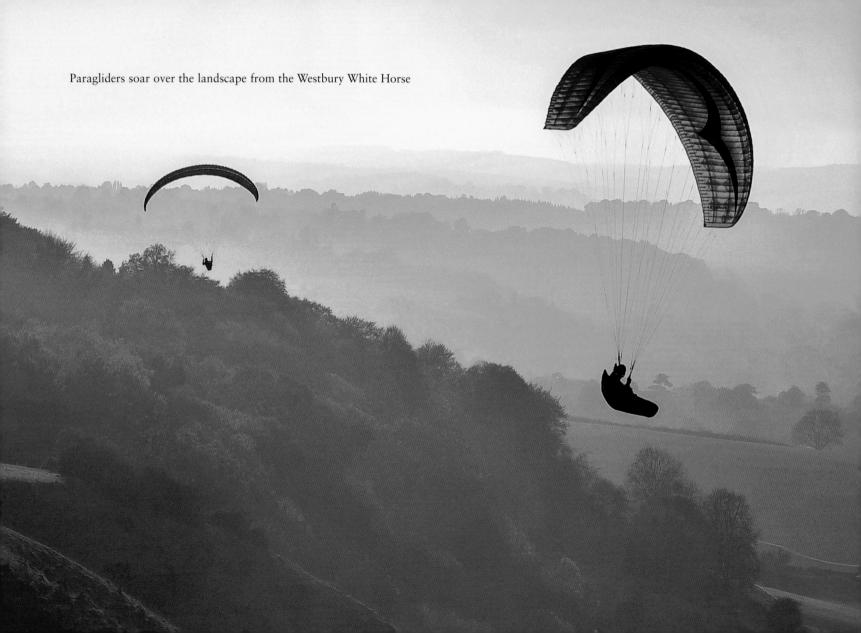

Paragliders soar over the landscape from the Westbury White Horse

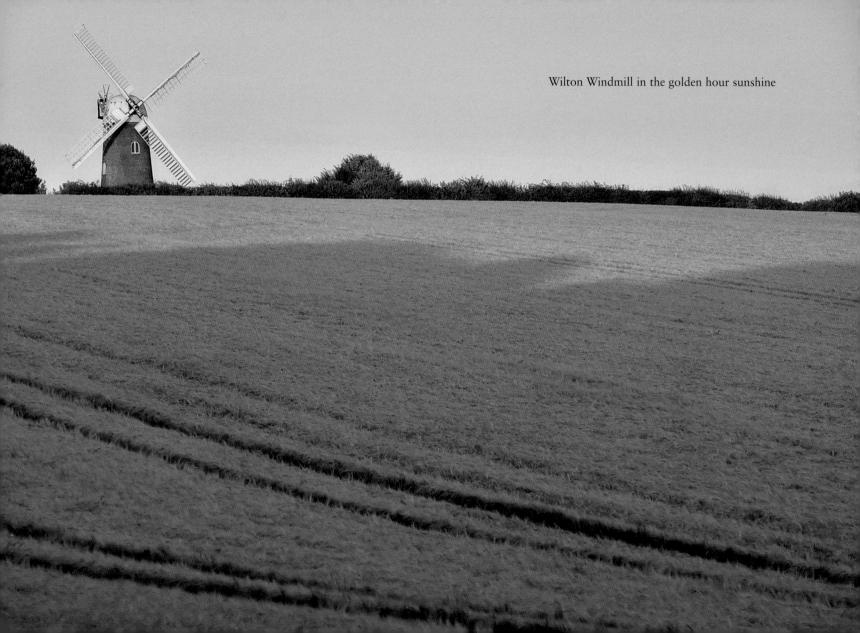

Wilton Windmill in the golden hour sunshine

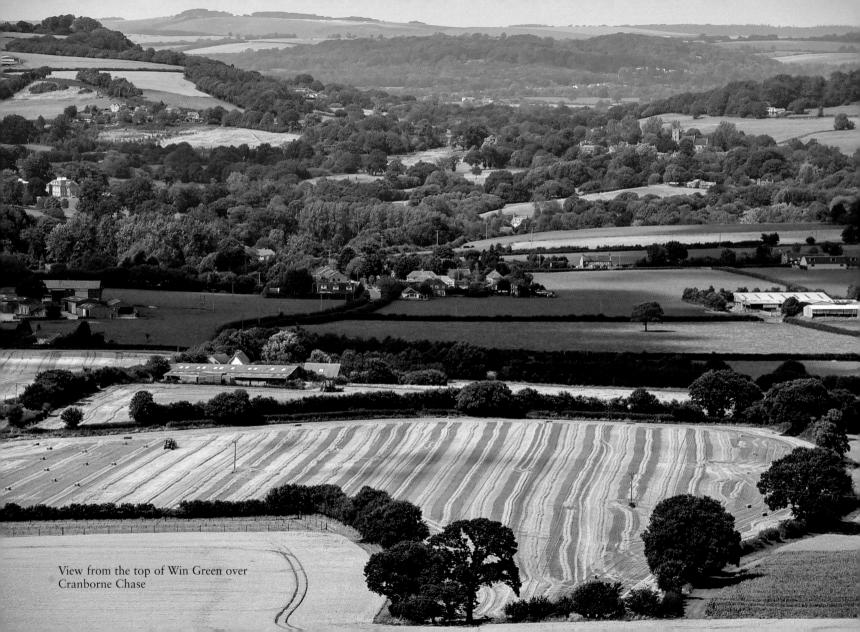

View from the top of Win Green over
Cranborne Chase

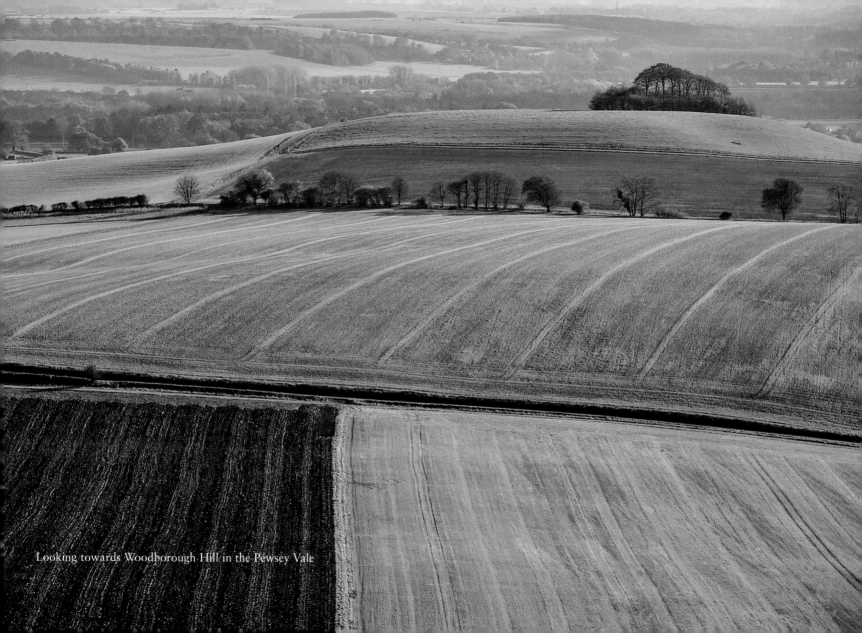

Looking towards Woodborough Hill in the Pewsey Vale

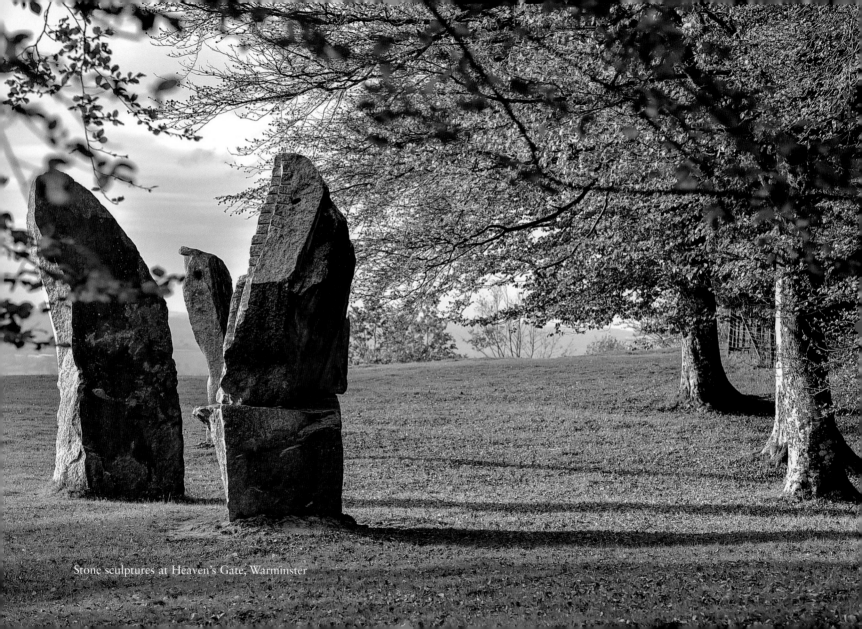

Stone sculptures at Heaven's Gate, Warminster

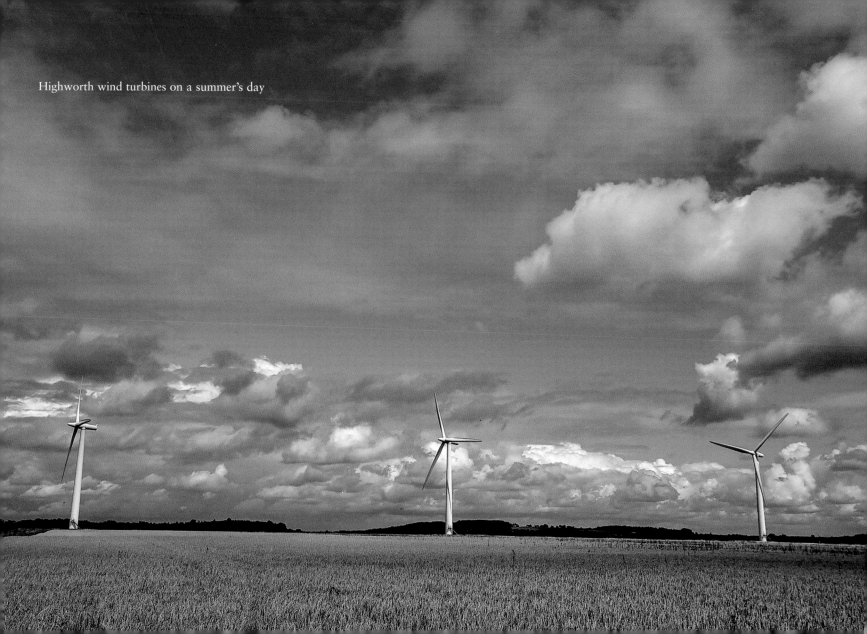

Highworth wind turbines on a summer's day

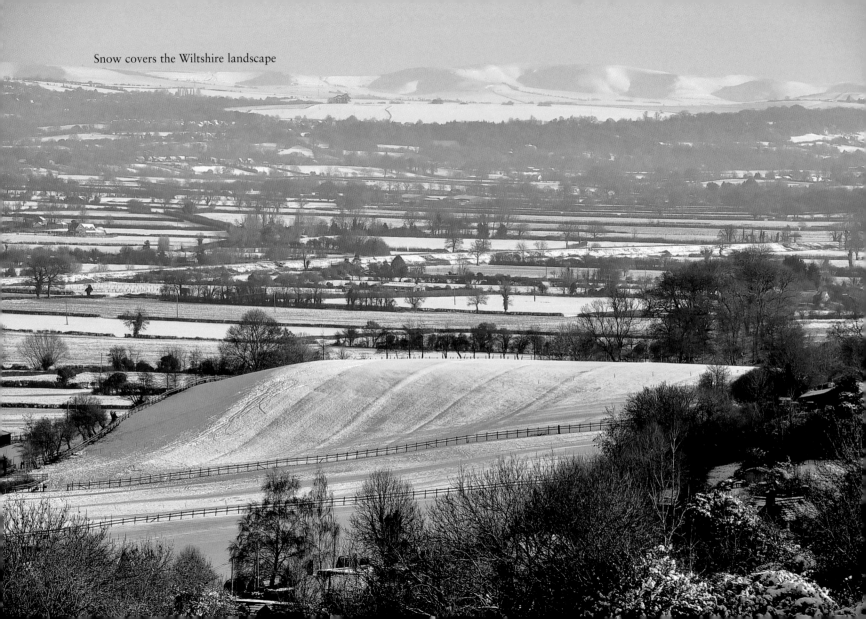

Snow covers the Wiltshire landscape

WATER AND WOODLANDS

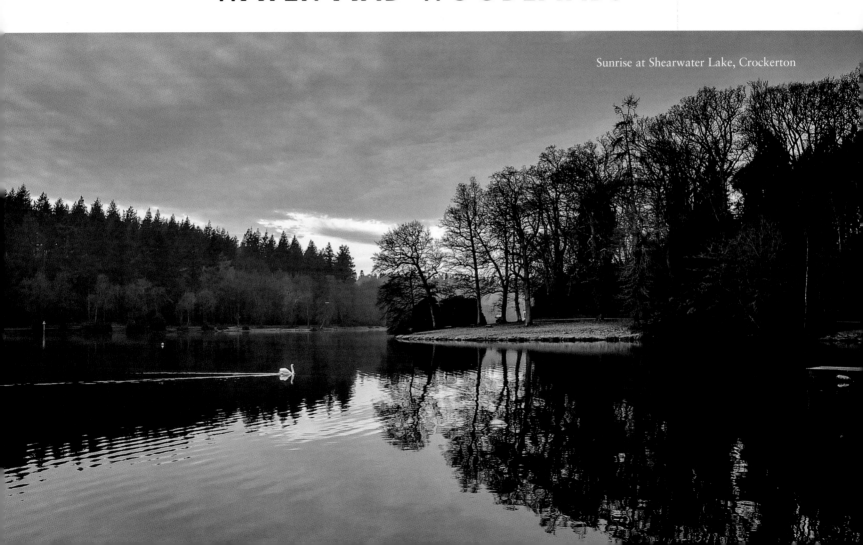

Sunrise at Shearwater Lake, Crockerton

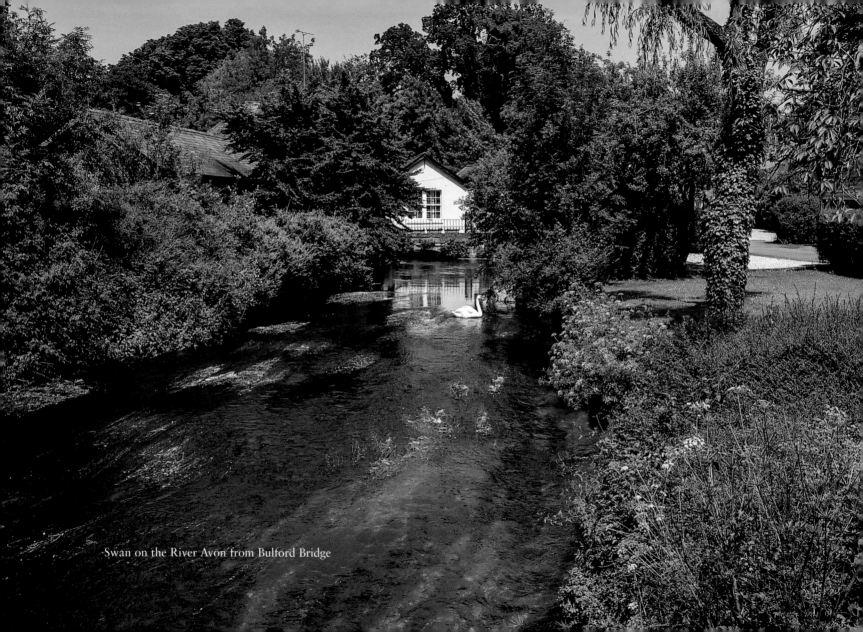

Swan on the River Avon from Bulford Bridge

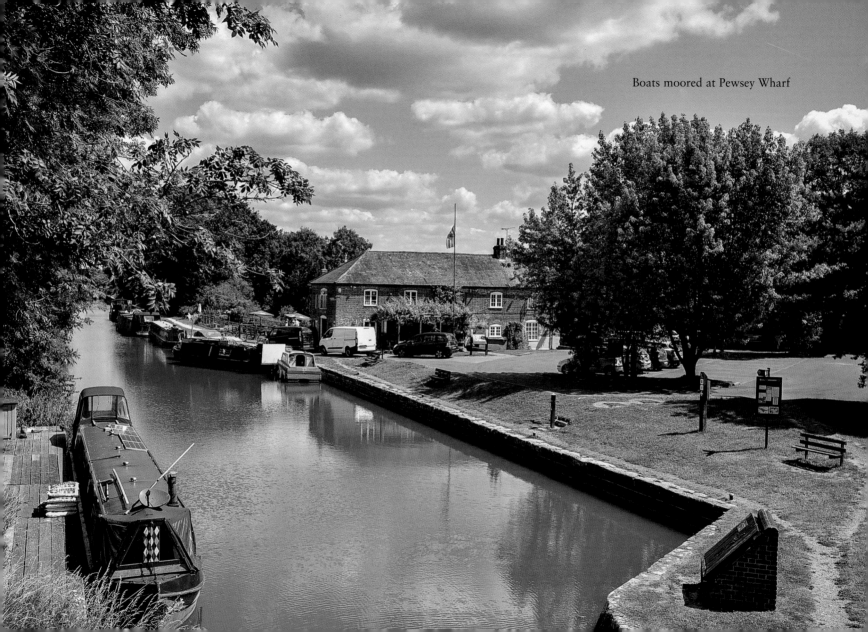

Boats moored at Pewsey Wharf

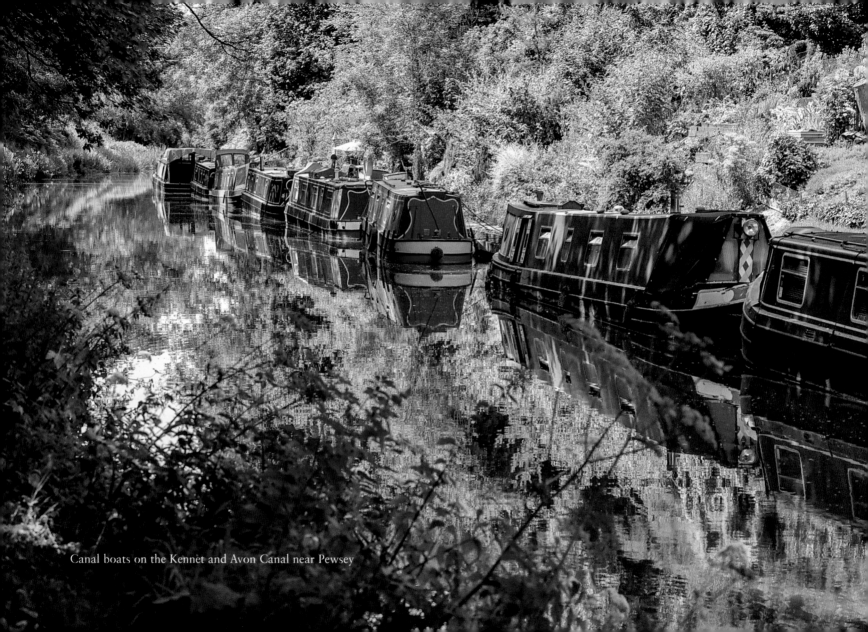

Canal boats on the Kennet and Avon Canal near Pewsey

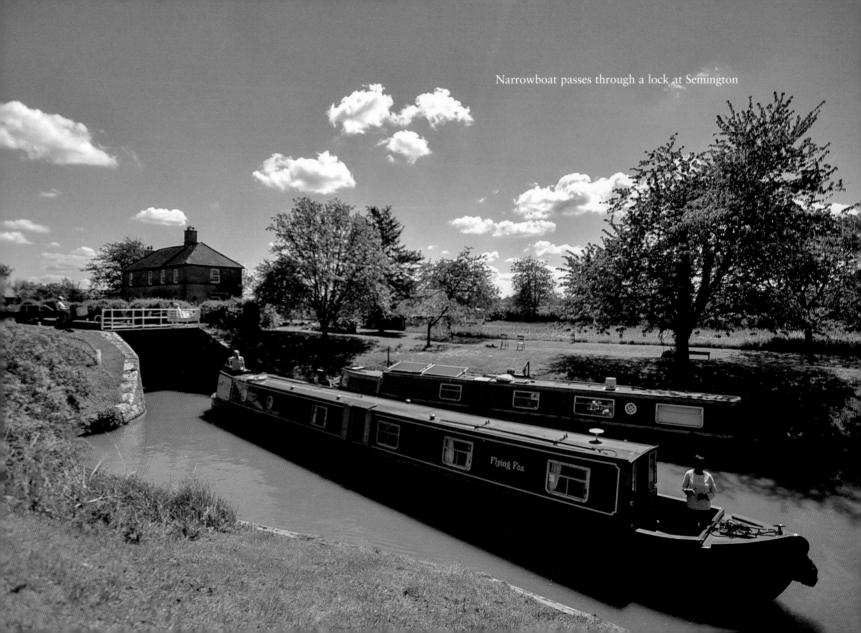
Narrowboat passes through a lock at Semington

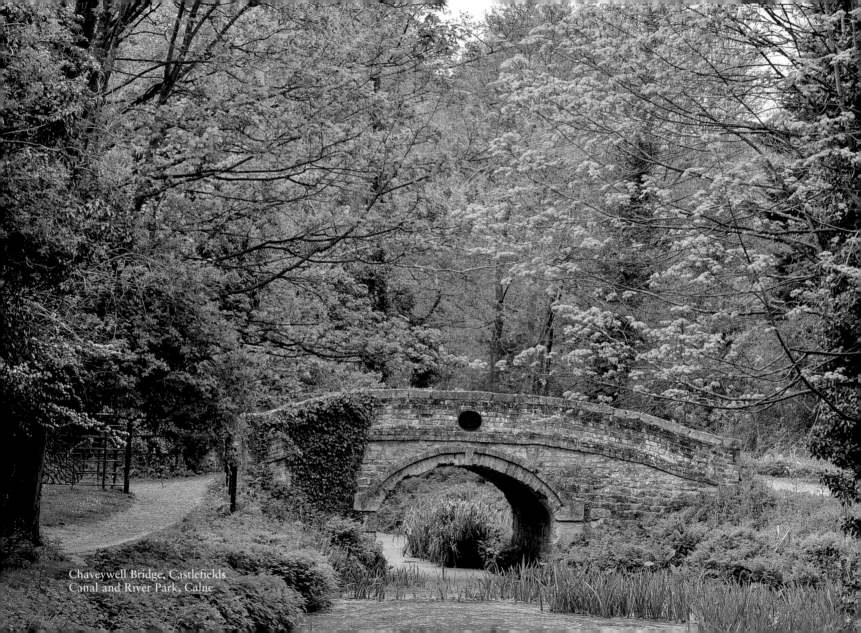

Chaveywell Bridge, Castlefields
Canal and River Park, Calne

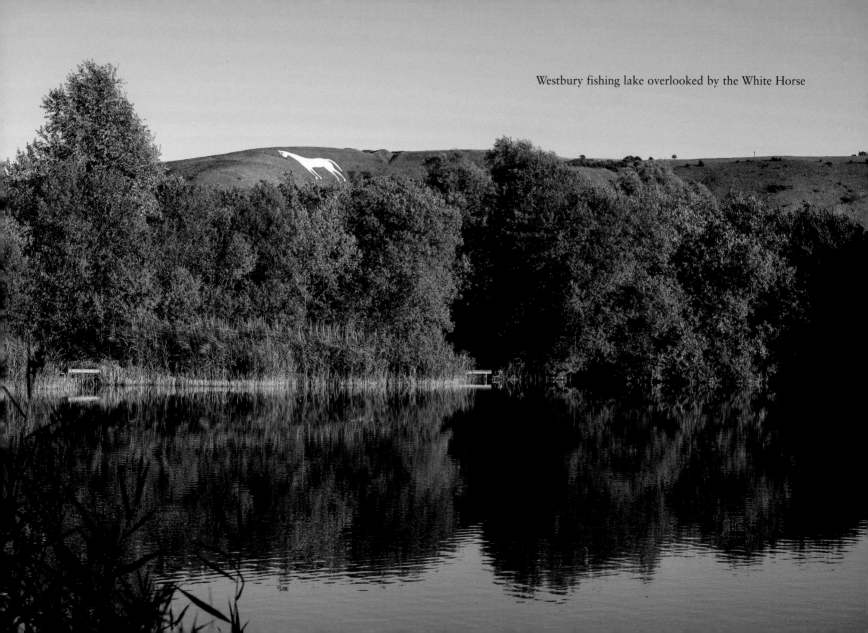

Westbury fishing lake overlooked by the White Horse

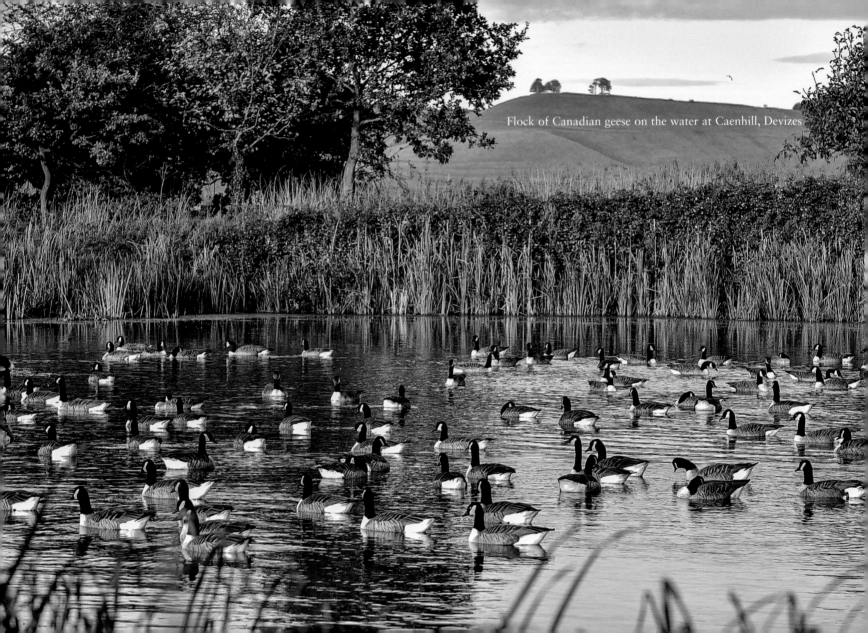

Flock of Canadian geese on the water at Caenhill, Devizes

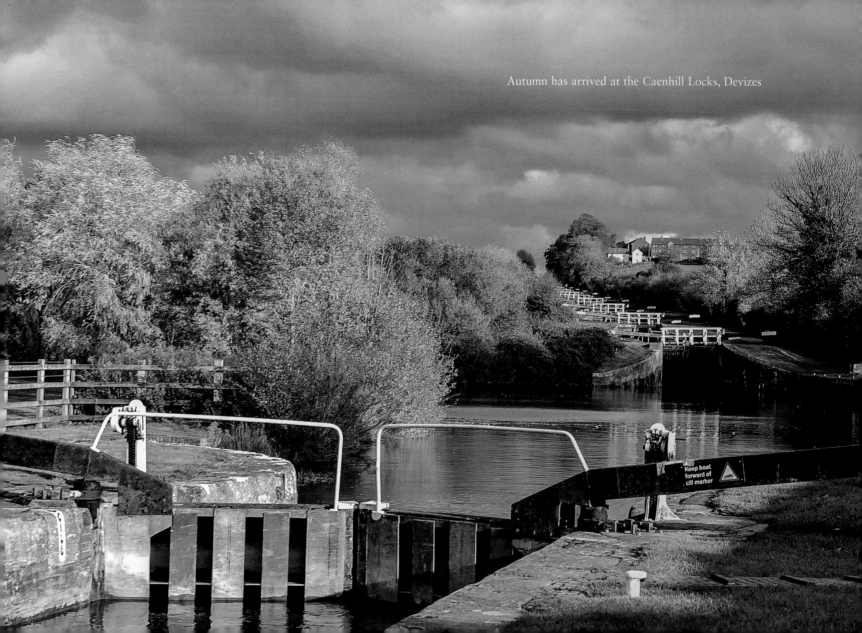

Autumn has arrived at the Caenhill Locks, Devizes

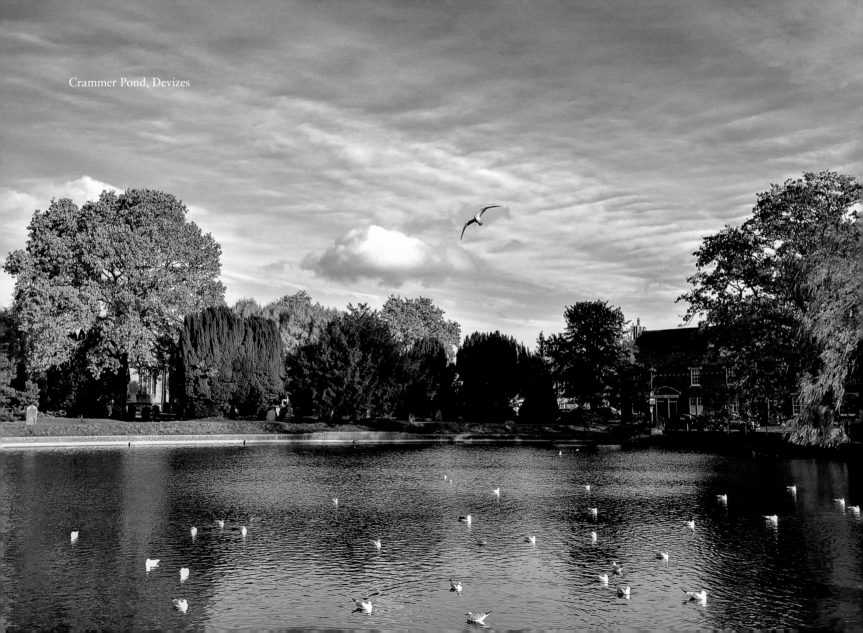

Crammer Pond, Devizes

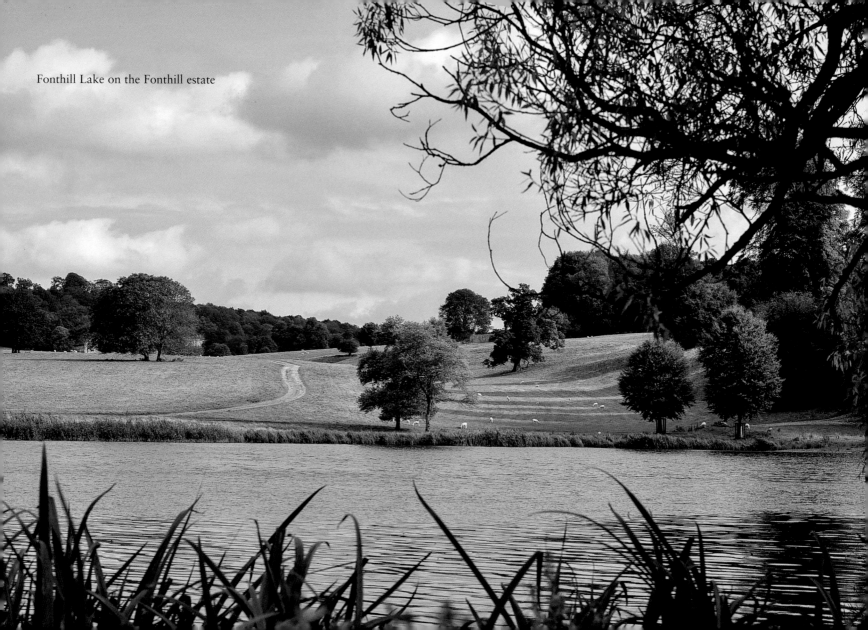
Fonthill Lake on the Fonthill estate

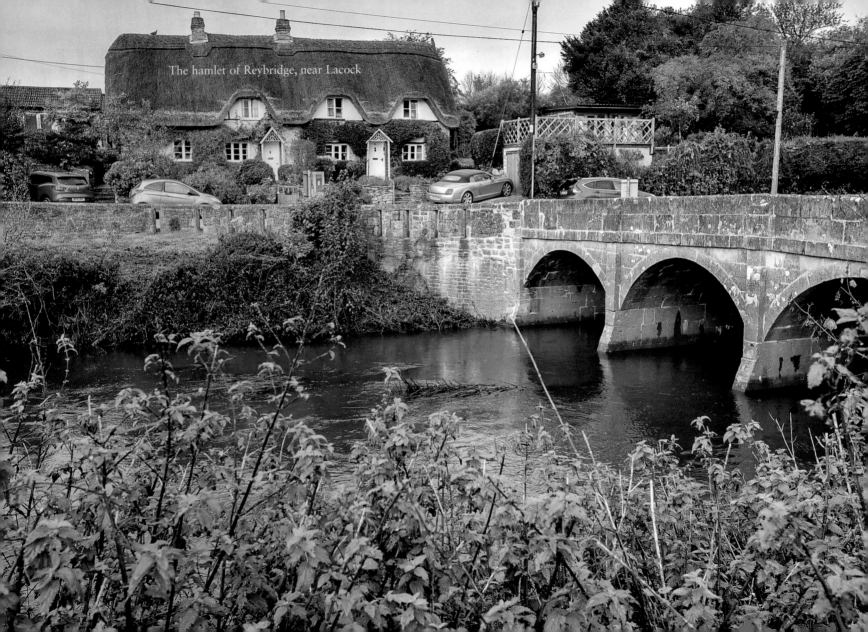

The hamlet of Reybridge, near Lacock

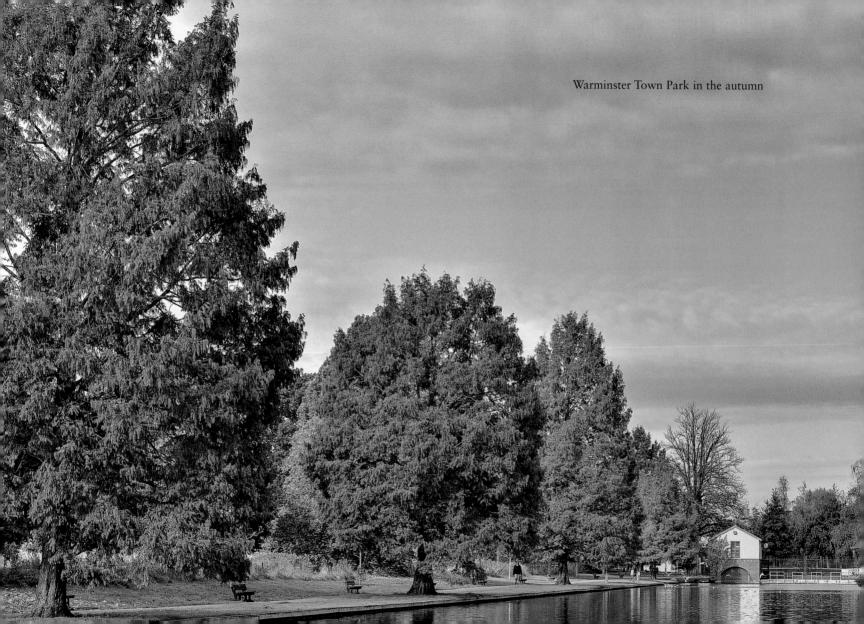

Warminster Town Park in the autumn

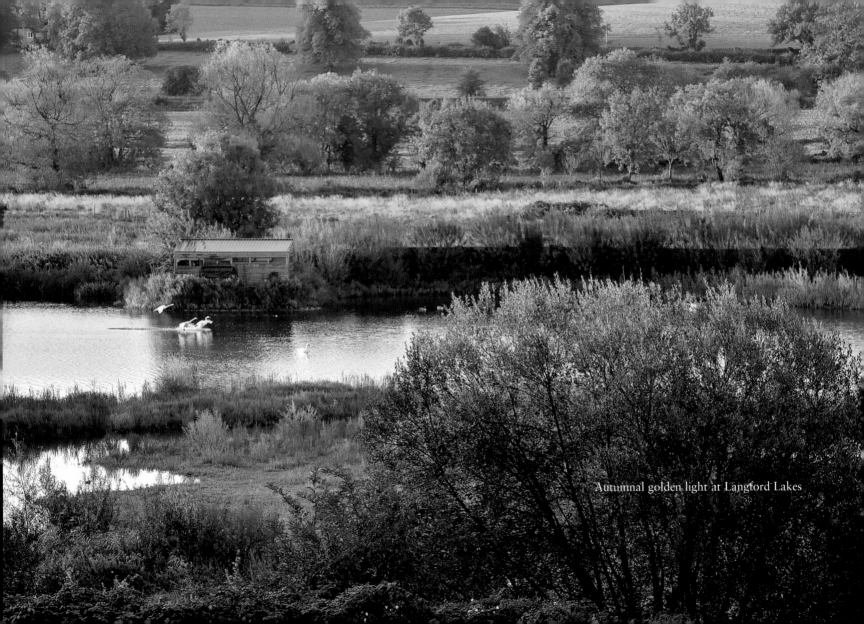

Autumnal golden light at Langford Lakes

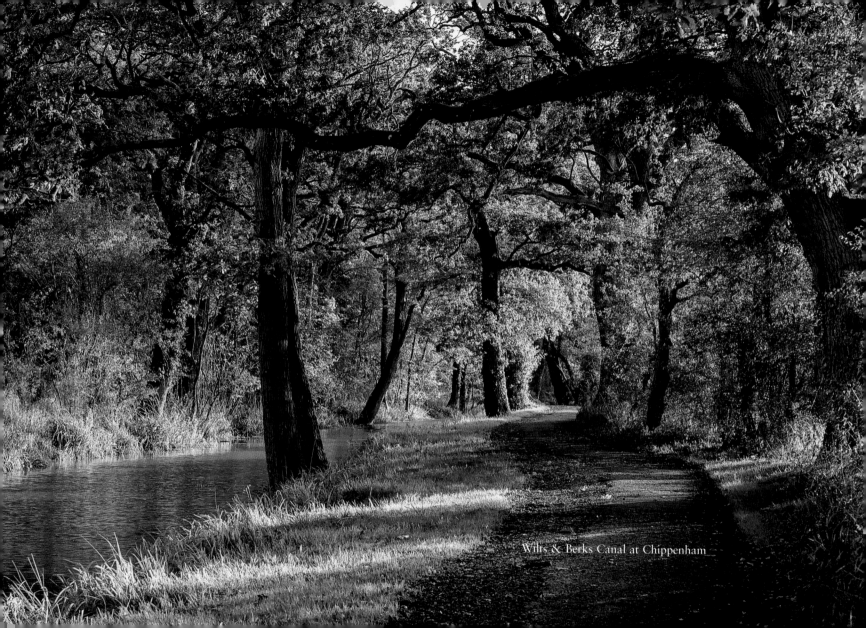

Wilts & Berks Canal at Chippenham

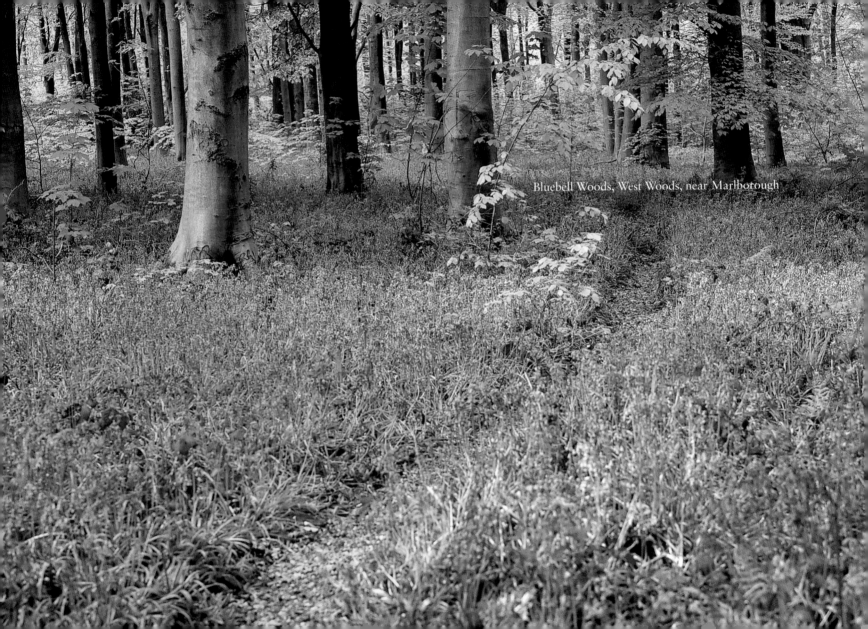

Bluebell Woods, West Woods, near Marlborough

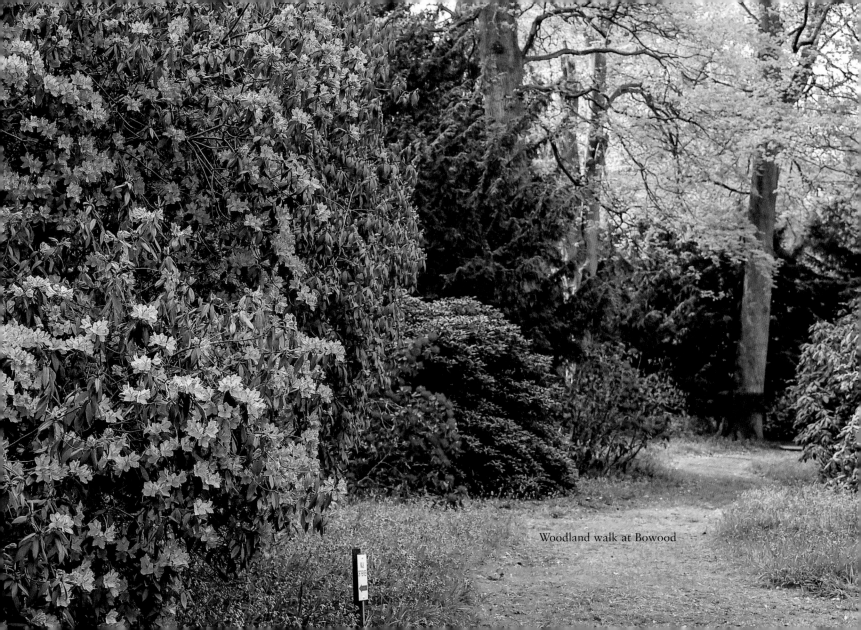

Woodland walk at Bowood

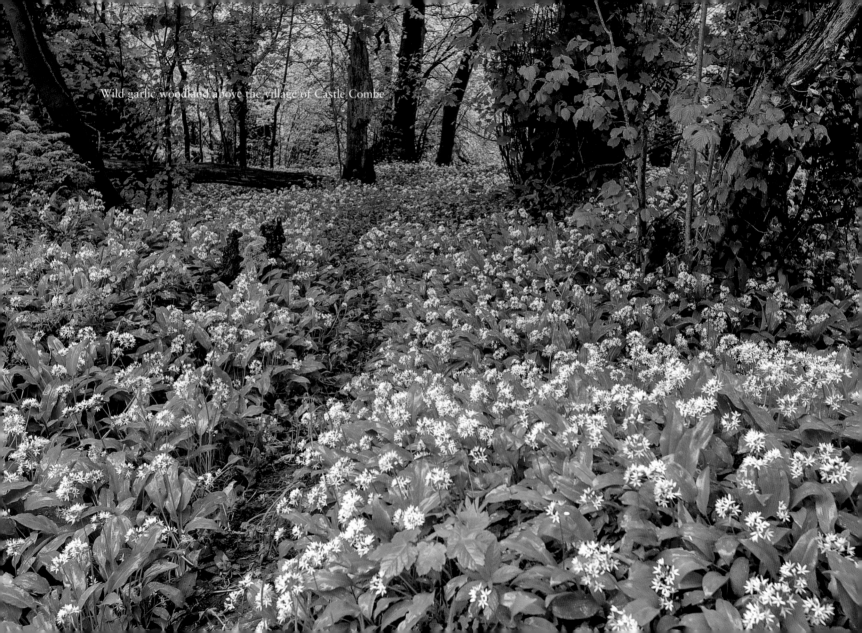

Wild garlic woodland above the village of Castle Combe

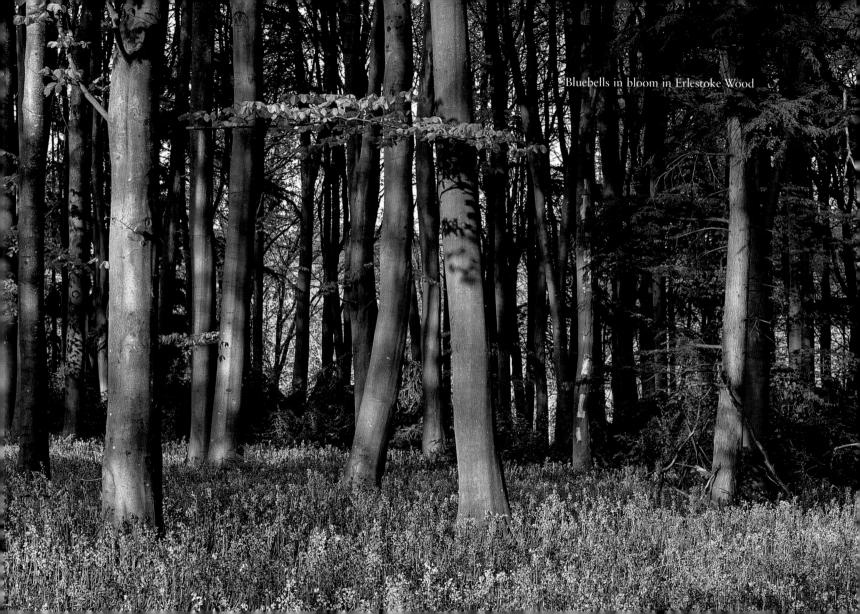
Bluebells in bloom in Erlestoke Wood

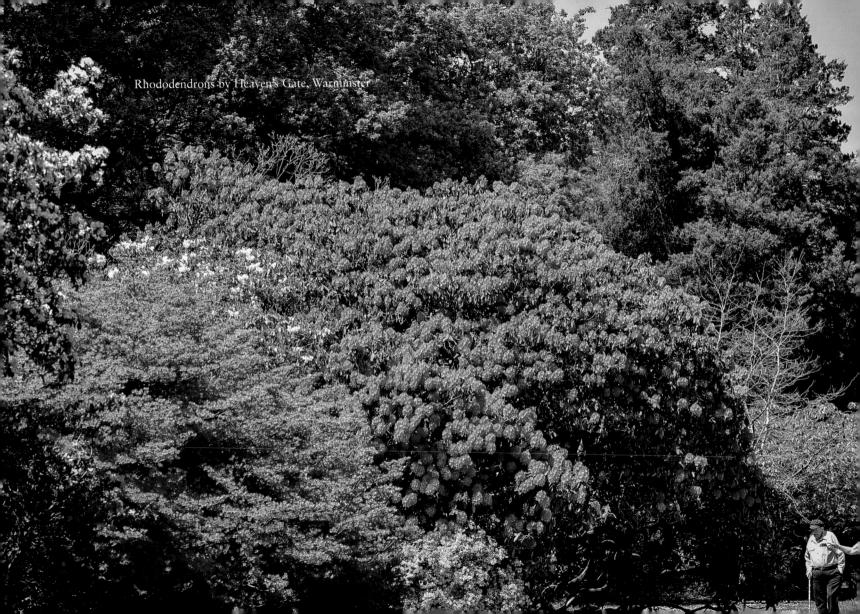

Rhododendrons by Heaven's Gate, Warminster

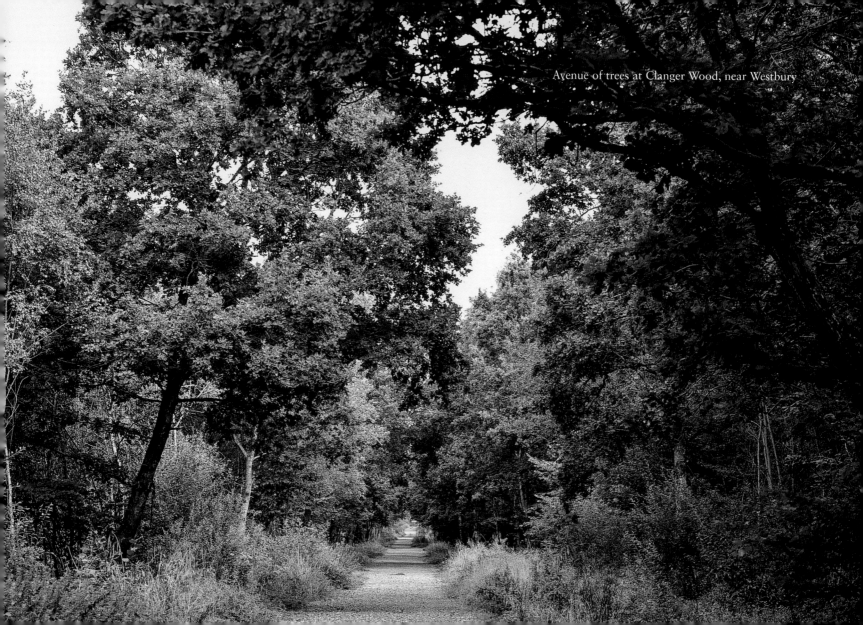

Avenue of trees at Clanger Wood, near Westbury

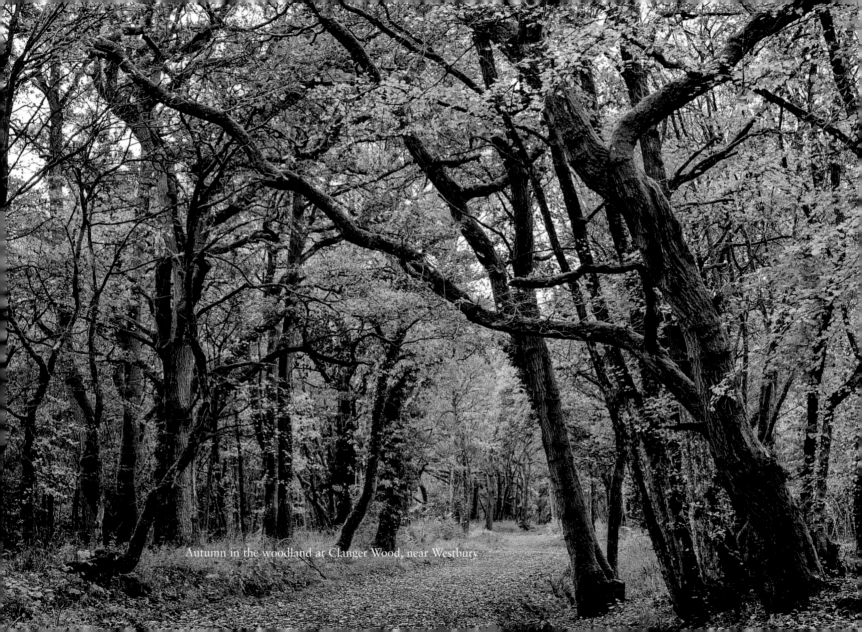

Autumn in the woodland at Clanger Wood, near Westbury

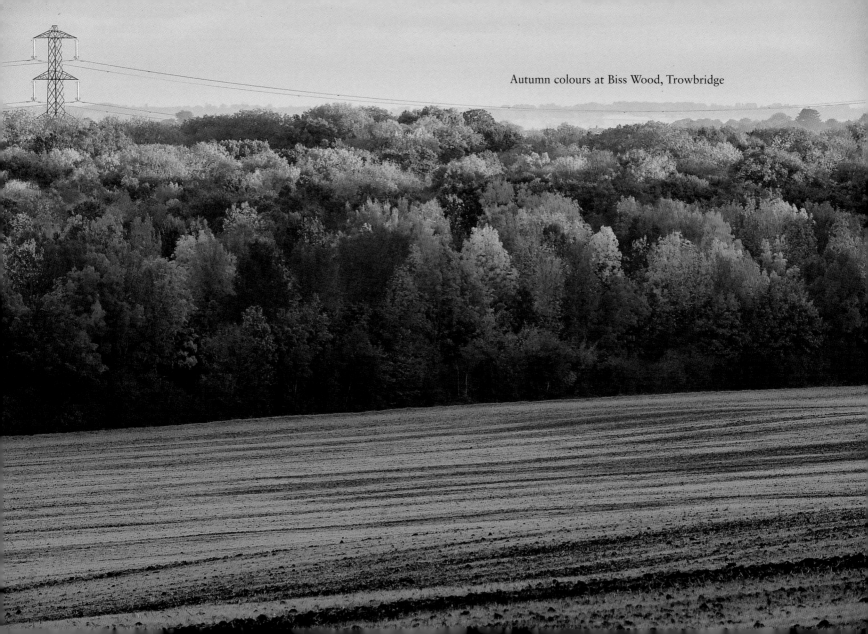

Autumn colours at Biss Wood, Trowbridge

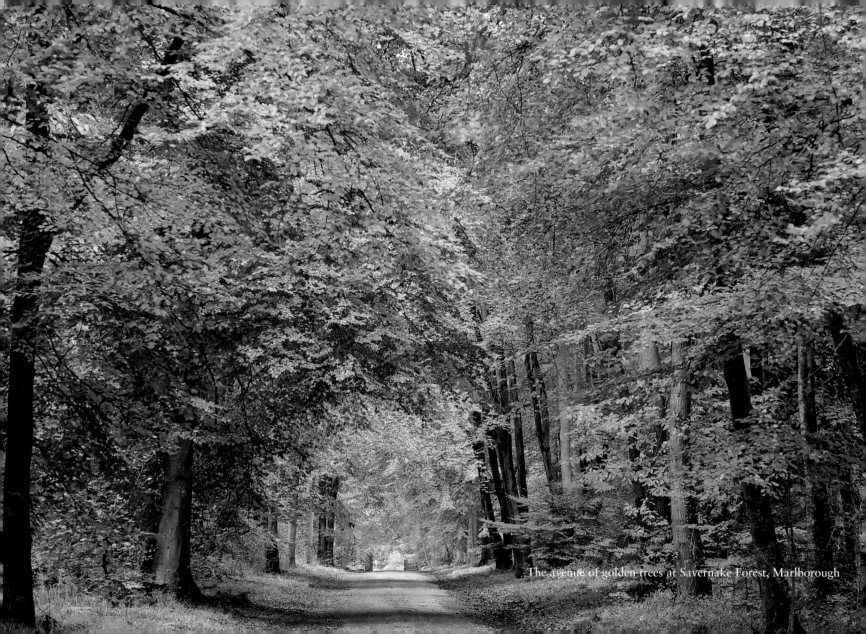

The avenue of golden trees at Savernake Forest, Marlborough